# Twin Cit

## impressions

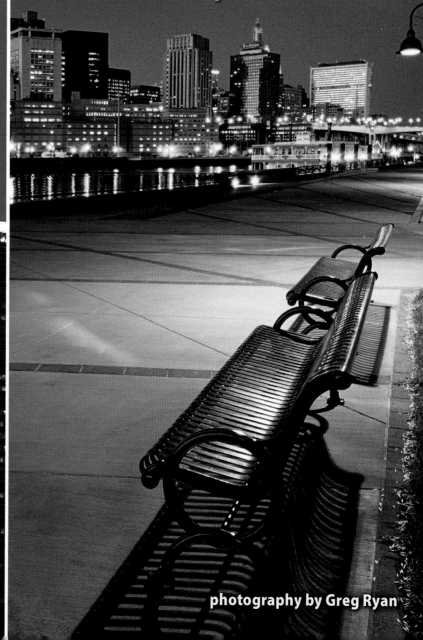

FARCOUNTRY PRESS

HELENA, MONTANA

photography by Greg Ryan

*To Marney Ryan, the love of my life.*

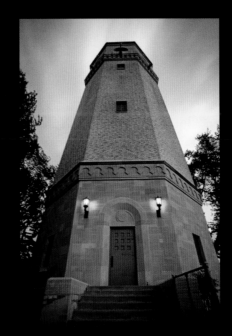

*Right:* Open the door and climb 151 steps for a splendid view from the observation deck high atop Highland Park Water Tower, built in St. Paul in 1928.

*Far right:* Rice Lake, part of Rice Creek Chain of Lakes Regional Park Reserve, glows with the warm colors of sunset.

*Title page:* The Minneapolis skyline serves as a backdrop for the Basilica of St. Mary at twilight (*left*). The Mississippi River reflects the lights of downtown St. Paul, as seen from Harriet Island Park (*right*).

*Cover:* The mighty Mississippi River figures prominently in the city life of St. Paul, at left, and Minneapolis, right. The capital city of St. Paul began as a boat landing and then railroad center. Minneapolis's early flour mills harnessed the power of the Mississippi River's St. Anthony Falls.

*Back cover:* Independence Day fireworks erupt above the Minnesota State Capitol in St. Paul.

ISBN 10: 1-56037-445-4
ISBN 13: 978-1-56037-445-9

© 2008 by Farcountry Press
Photography © 2008 by Greg Ryan

For more information about our books, write Farcountry Press, P.O. Box 5630, Helena, MT 59604; call (800) 821-3874; or visit www.farcountrypress.com.

Created, produced, and designed in the United States.
Printed in China.

13  12  11  10  09  08     1  2  3  4  5  6

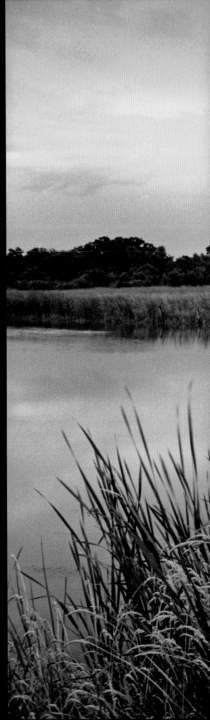

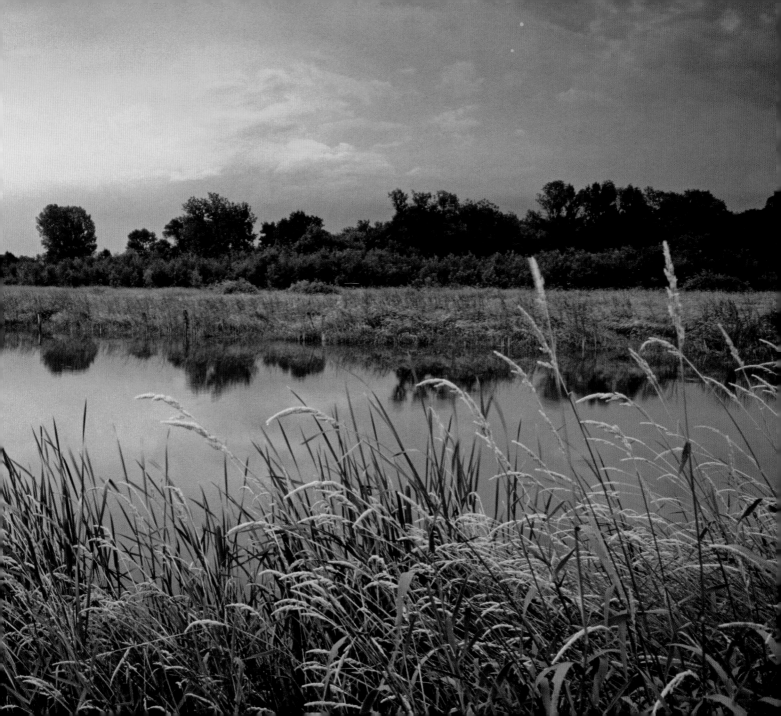

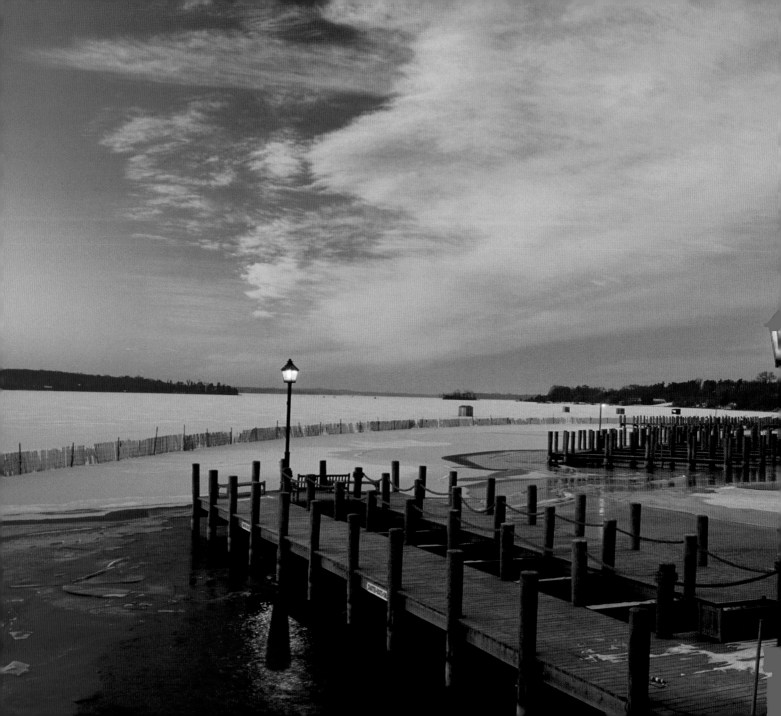

*Left:* The pastel hues of sunrise color patches of open water surrounding the docks in Wayzata Bay on Lake Minnetonka.

*Below:* Victorian-era streetlights add charm to the Minneapolis Riverfront, a former flour-milling district.

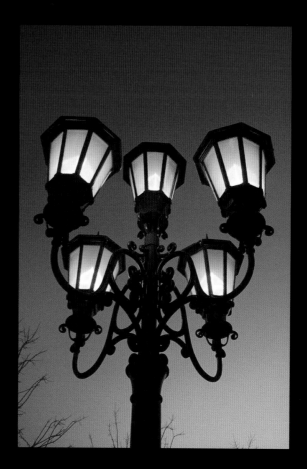

*Right and below:* Hardy, varied, fall–blooming chrysanthemums can brighten an autumn day at Peavey Plaza like no other flower (*below*). Masses of them fill the Sunken Garden in St. Paul's Marjorie McNeely Conservatory at Como Park (*right*) for the annual Fall Flower Show.

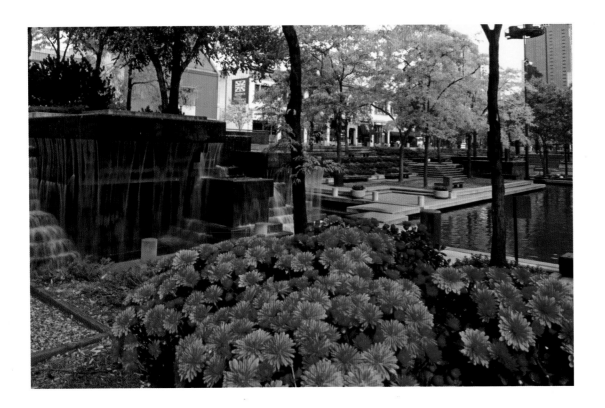

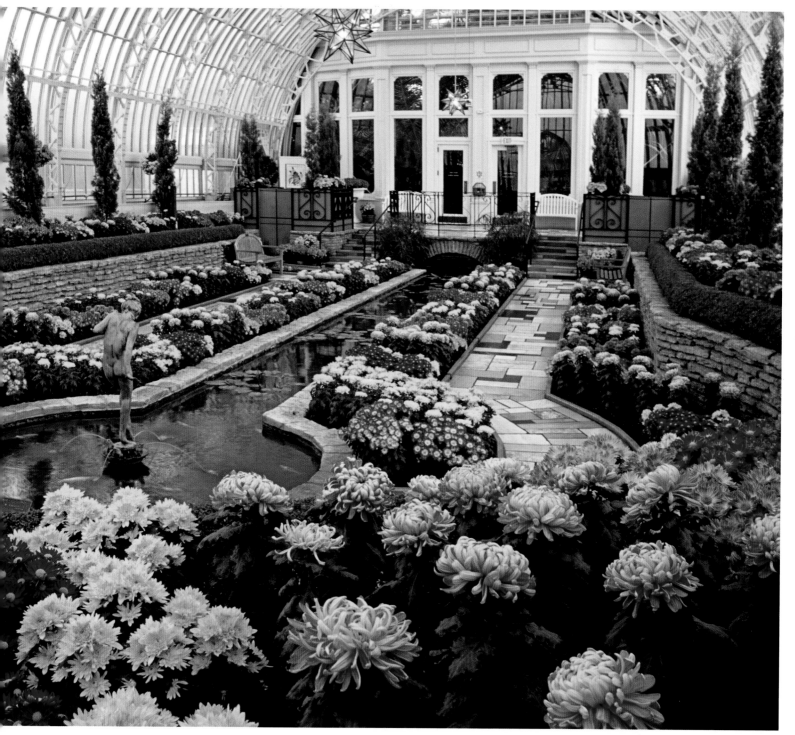

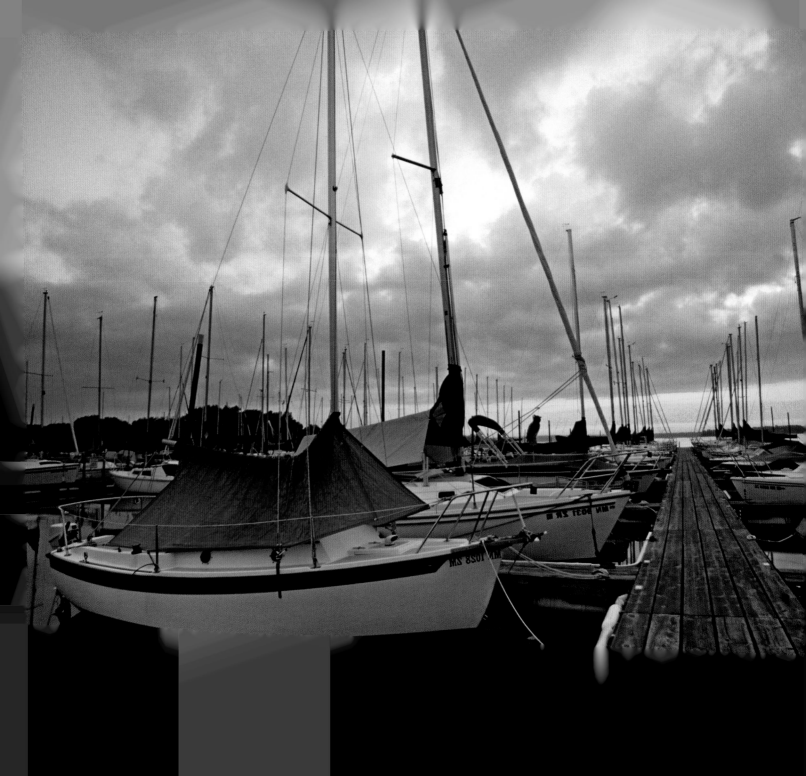

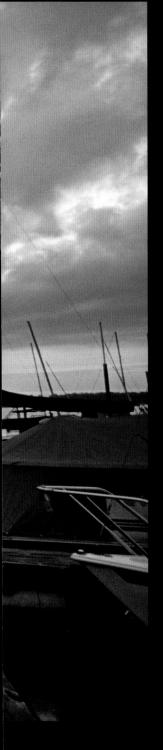

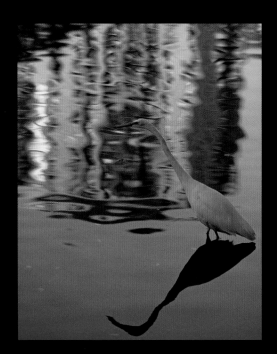

*Left:* A great egret watches for prey in Loring Lake, in the heart of downtown Minneapolis.

*Far left:* Sailboats await their captains on a summer morning at White Bear Lake.

*Below:* A Canada goose pair swims on a city lake in early autumn.

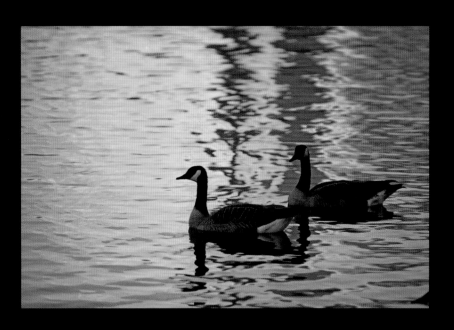

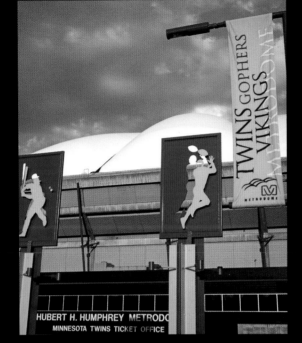

*These pages:* Fans head for the Hubert H. Humphrey Metrodome, which houses the Minnesota Twins Major League Baseball team, the National Football League's Minnesota Vikings, and the University of Minnesota Golden Gophers. Even the artwork outside the dome reflects its many uses.

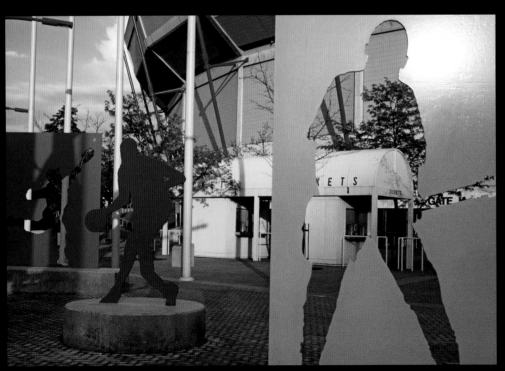

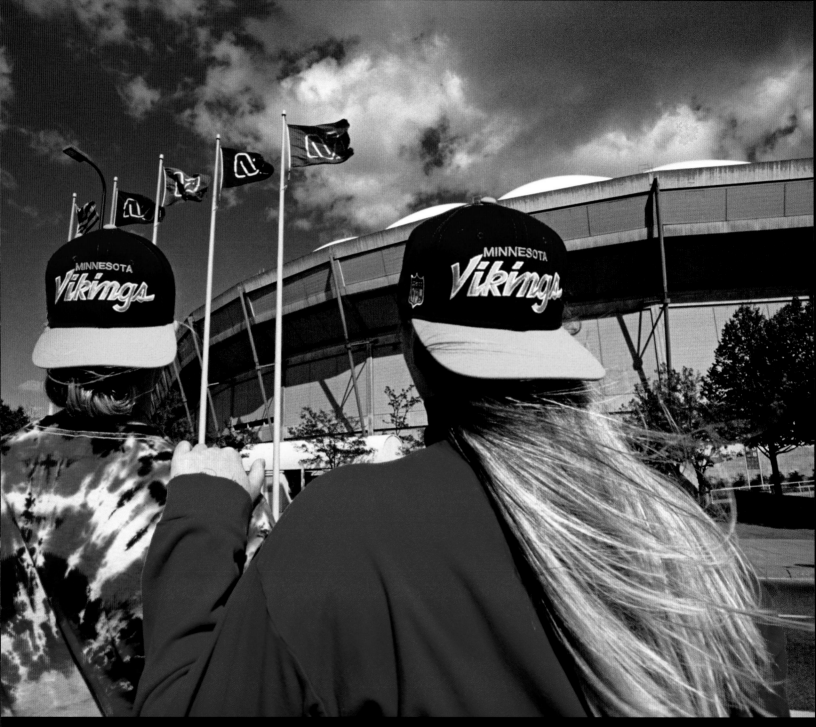

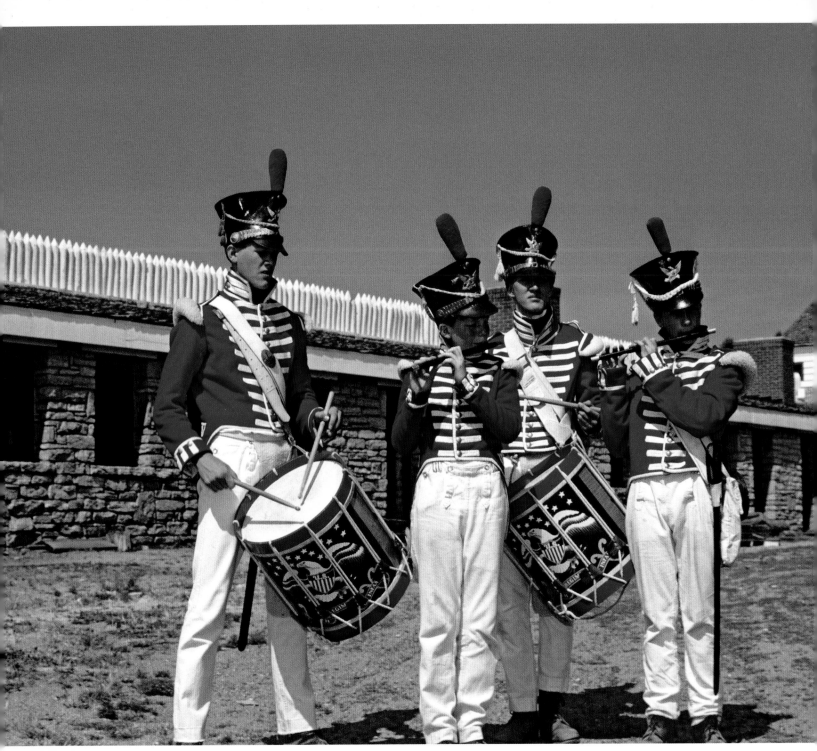

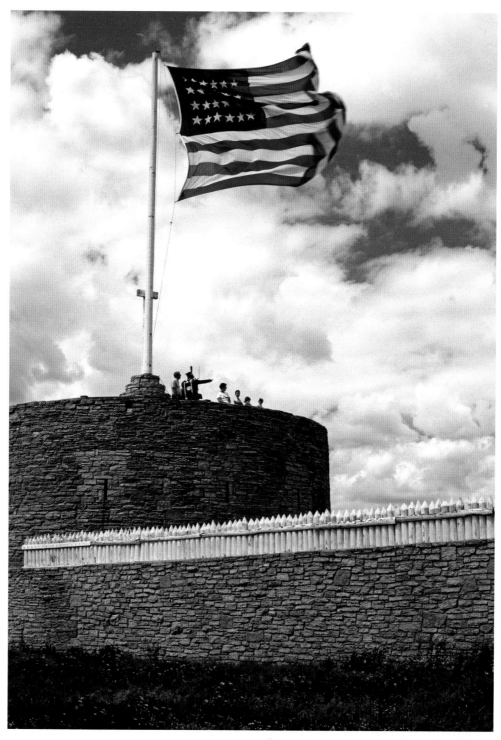

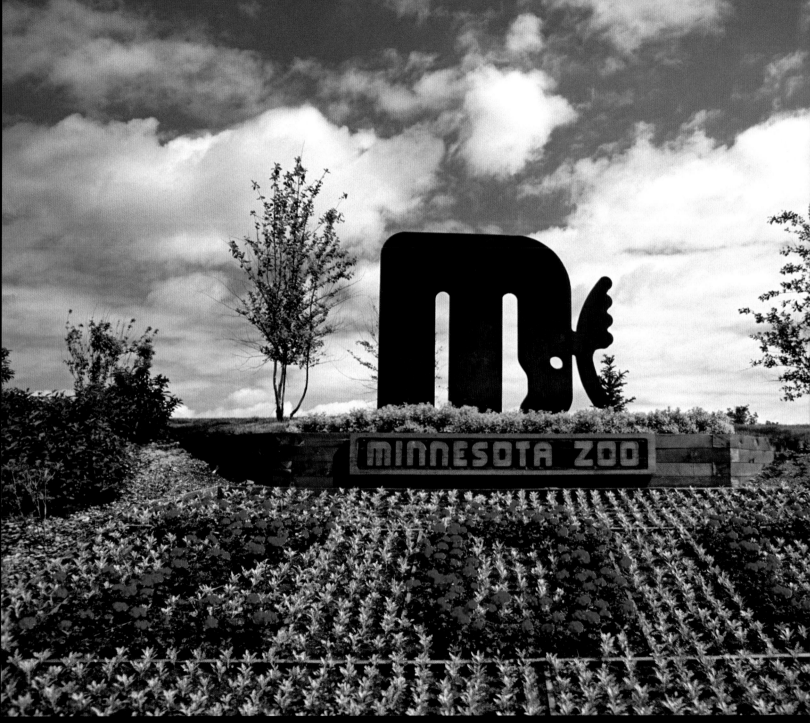

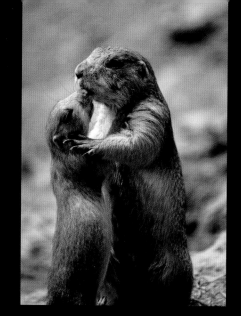

*These pages:* A whimsical moose sculpture and colorful plants (*facing page*) announce the entrance to the 500–acre Minnesota Zoo. Located in Apple Valley, the zoo is home to nearly 2,300 animals, from prairie dogs (*left*) to Siberian tigers (*below*).

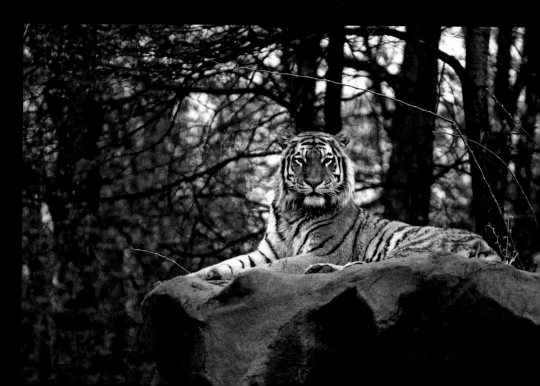

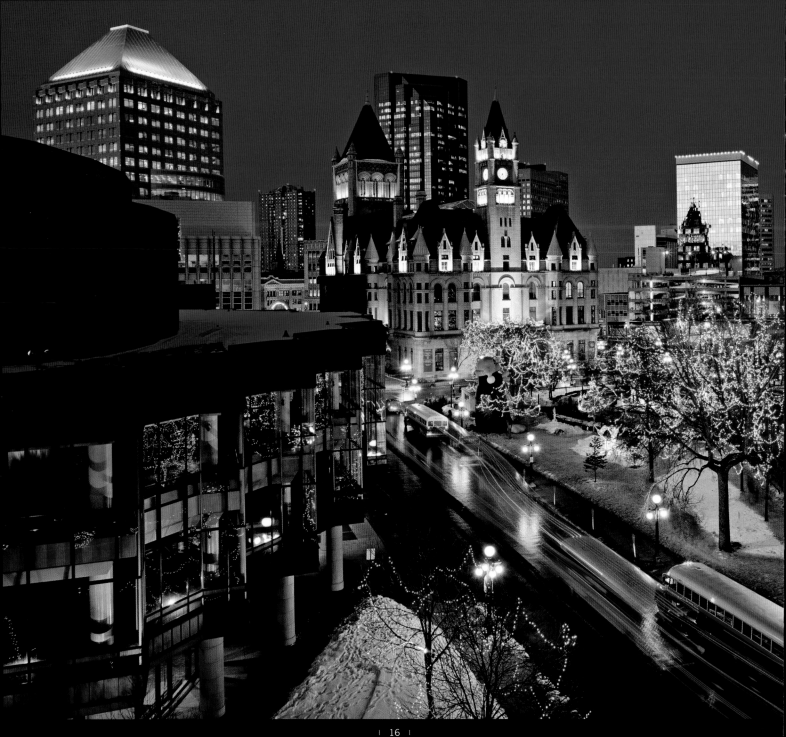

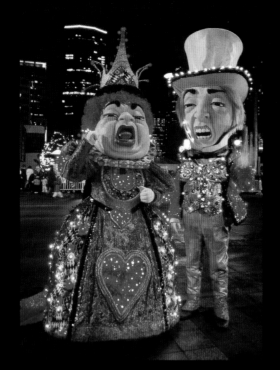

**Left and below:** Outlandish, illuminated characters bring festive fun to the Holidazzle Parade each year in downtown Minneapolis.

**Far left:** Opposite the Ordway Center for the Performing Arts, sparkling holiday lights make St. Paul's Rice Park and its surroundings look like a fairyland.

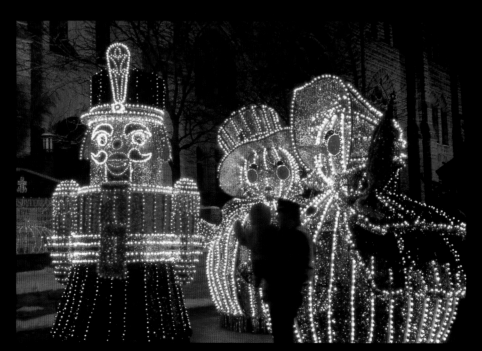

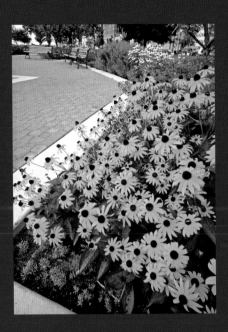

*Right:* Colorful flowers such as Rudbeckia, seen here in St. Paul's Mississippi Riverfront, brighten the Twin Cities all summer.

*Far right:* Profuse spring blossoms take your breath away in Center Square, located in the Irvine Park Historic District of St. Paul.

*Below:* Lyndale Park's Oriental Garden achieves a sweet serenity in South Minneapolis.

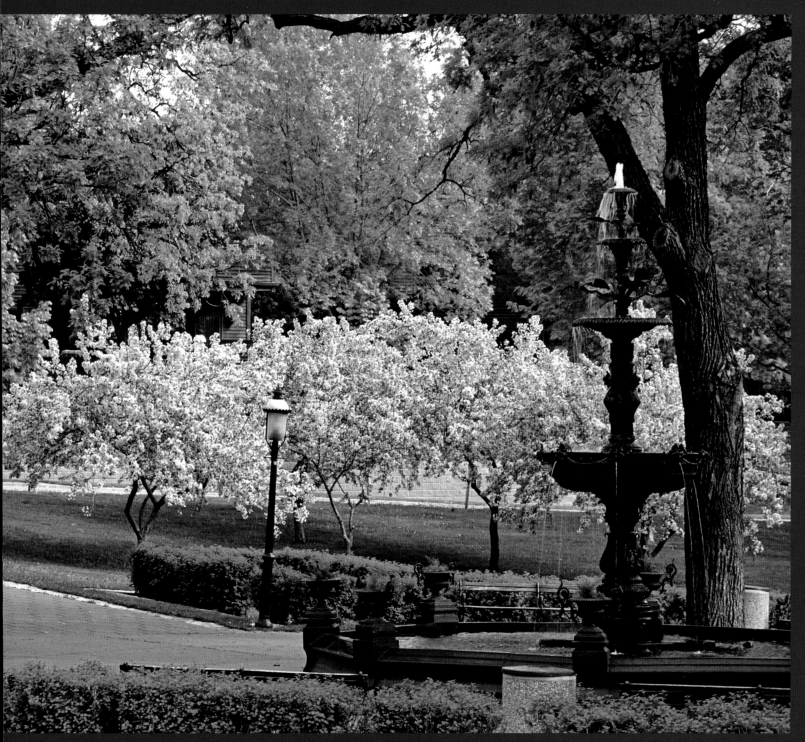

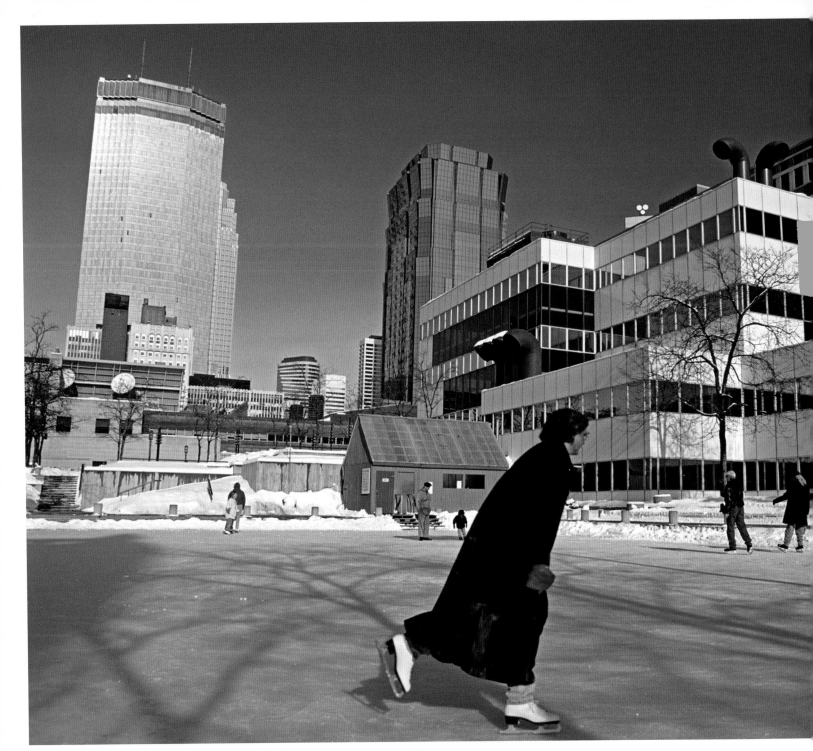

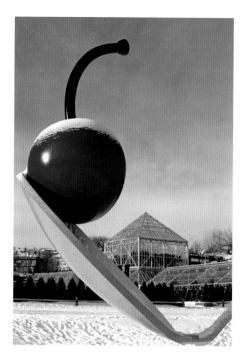

**Left:** The *Spoonbridge and Cherry* fountain adds a whimsical element to the Minneapolis Sculpture Garden.

**Far left:** Peavey Plaza holds ice nicely, inviting skaters to take a spin around this rink near Orchestra Hall in downtown Minneapolis.

**Below:** Who said winter is boring? St. Paul's annual Winter Carnival inspires people to create these inventive snow sculptures.

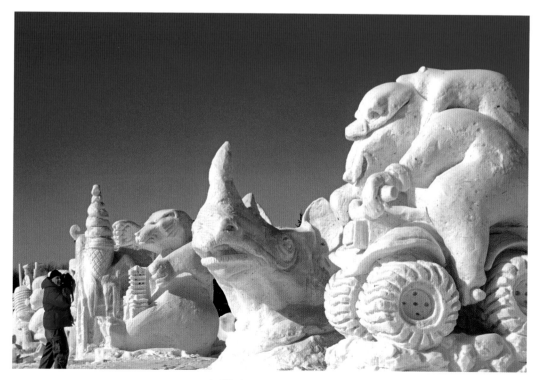

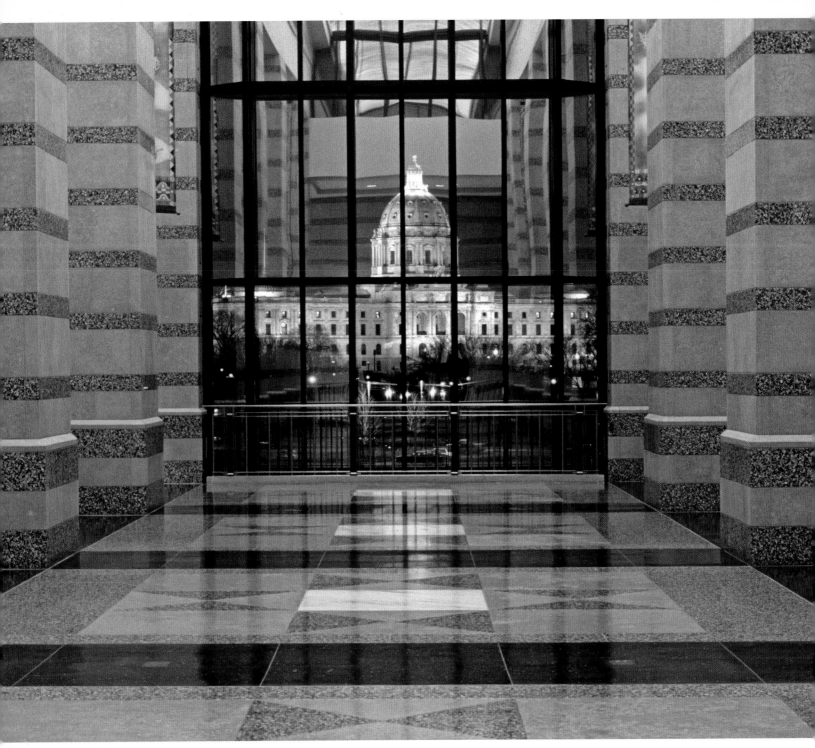

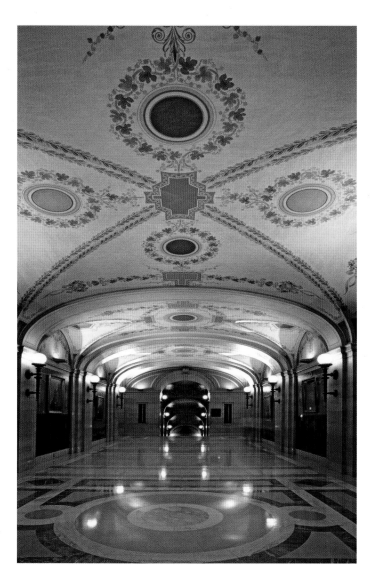

*Left:* The magnificent interior of the Minnesota State Capitol in St. Paul is polished and ready for the next flurry of government meetings.

*Facing page:* The stately Minnesota History Center in St. Paul directs your eye to a perfect view of the state capitol.

*Below:* Daniel Chester French—sculptor of the Lincoln Memorial in Washington, D.C.—designed *Progress of the State*, seven golden figures that sit above the south portico at the main entrance to the Minnesota State Capitol in St. Paul.

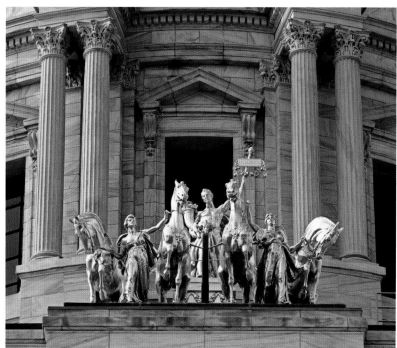

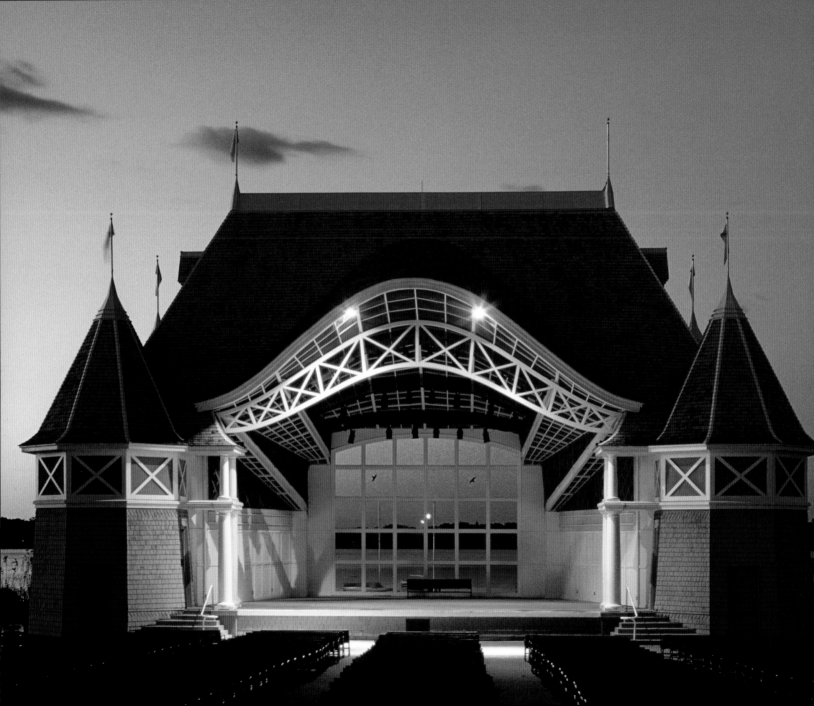

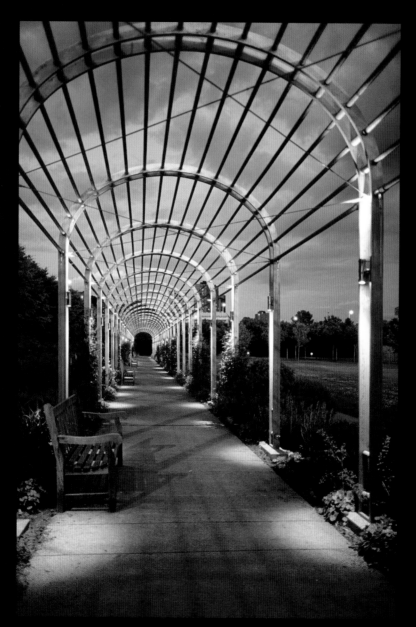

*Left:* The vine-covered, 300-foot-long Alene Grossman Memorial Arbor runs along the northern boundary of the Minneapolis Sculpture Garden.

*Far left:* Lake Harriet Pavilion in South Minneapolis has featured live music since 1888.

*Right:* A magnolia tree toughs out a late-spring snowstorm at the Minnesota Landscape Arboretum in Chanhassen.

*Below:* This healthy, thick-furred coyote lives at the Minnesota Zoo.

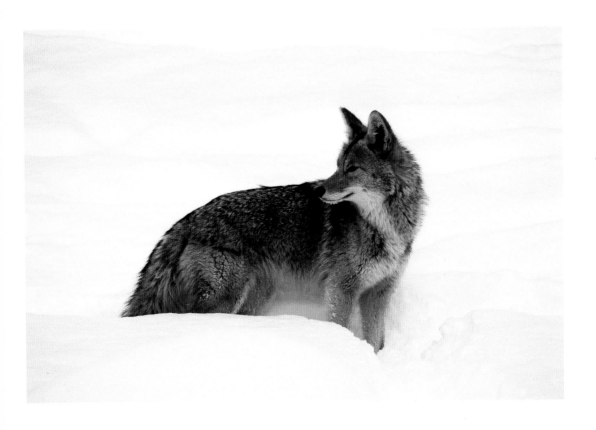

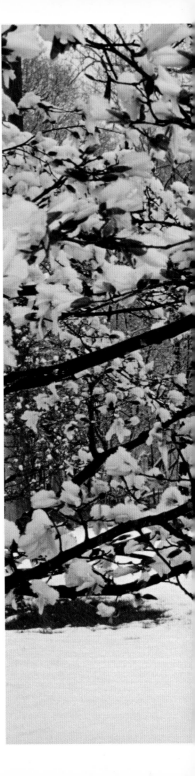

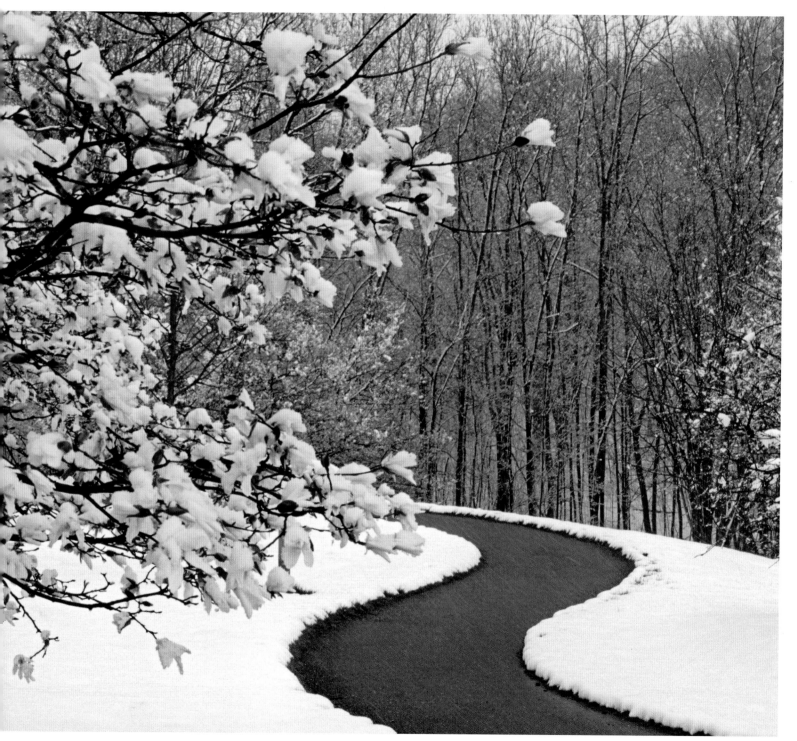

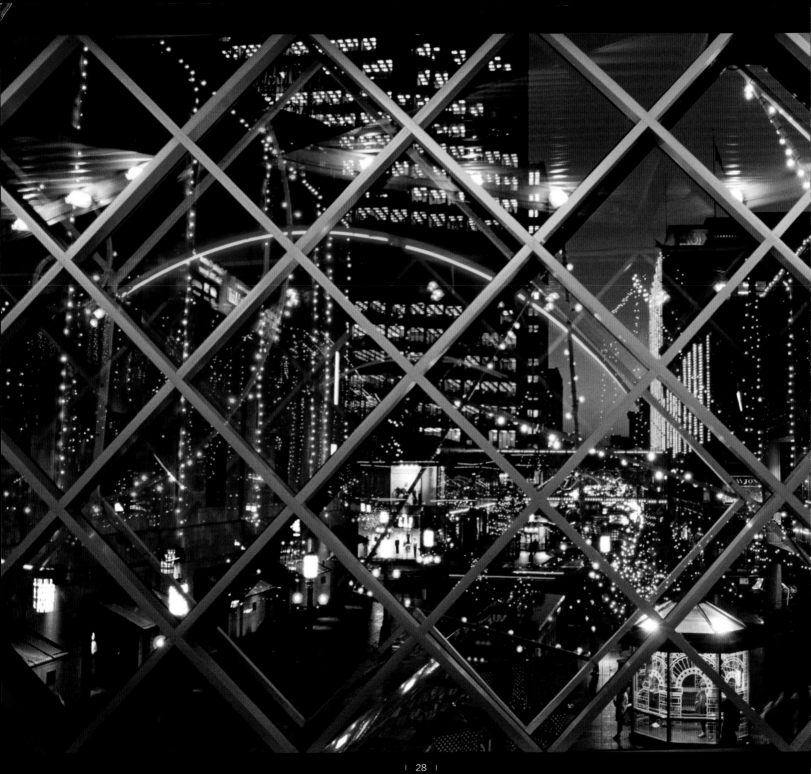

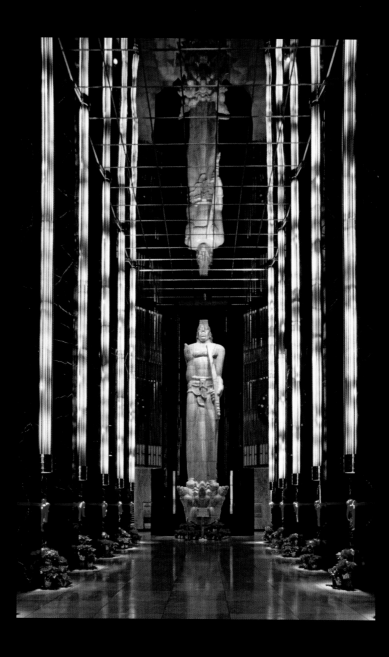

*Left: Vision of Peace* inside the St. Paul City Hall and Ramsey County Courthouse. This Mexican onyx statue is thirty–six feet tall and weighs approximately sixty tons.

*Far left:* Skyways throughout downtown Minneapolis shelter pedestrians from wintry weather. Here, a skyway's geometric window provides an interesting view of the animated holiday scene.

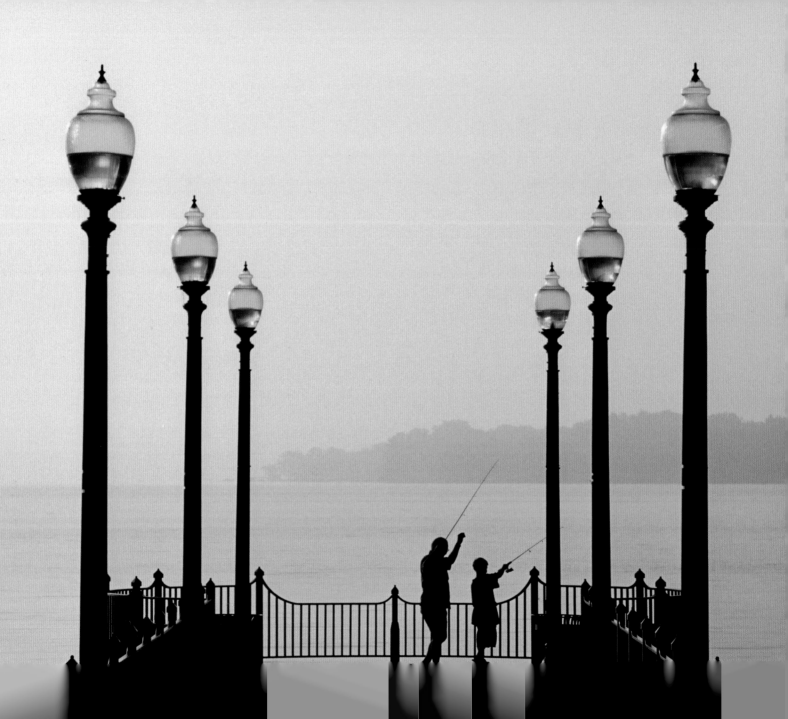

*Facing page:* The fish in White Bear Lake provide a perfect excuse for an outing for this grandfather and grandson.

*Below:* A great blue heron stands motionless along the Mississippi River near downtown St. Paul.

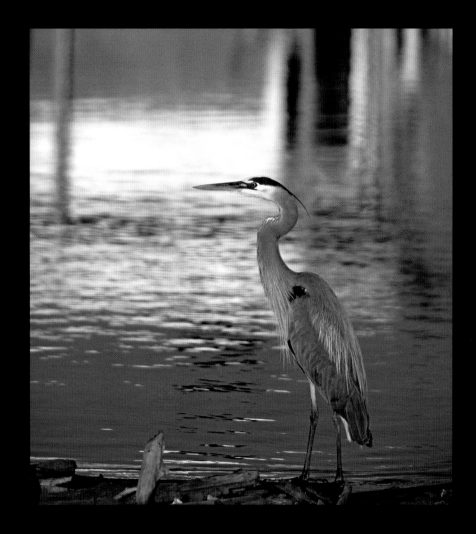

*Right:* Minneapolis's Guthrie Theater showcases regional, national, and international productions.

*Far right:* The popular Science Museum of Minnesota in St. Paul offers changing exhibits, interactive displays, and IMAX films.

*Below:* The Mill City Museum chronicles the history of the flour-milling industry that flourished here on the banks of the Mississippi River, fueling the growth of Minneapolis.

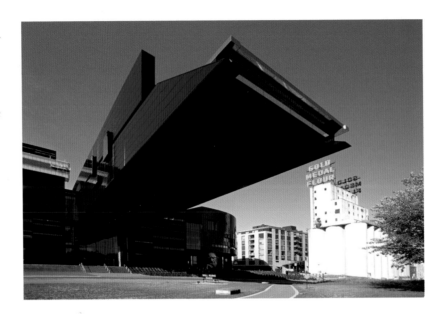

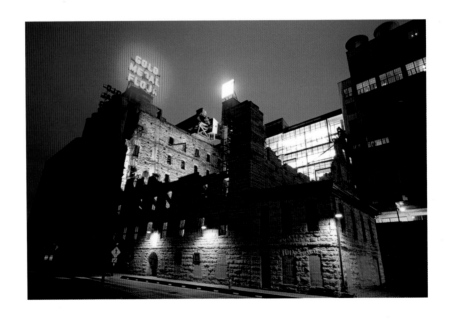

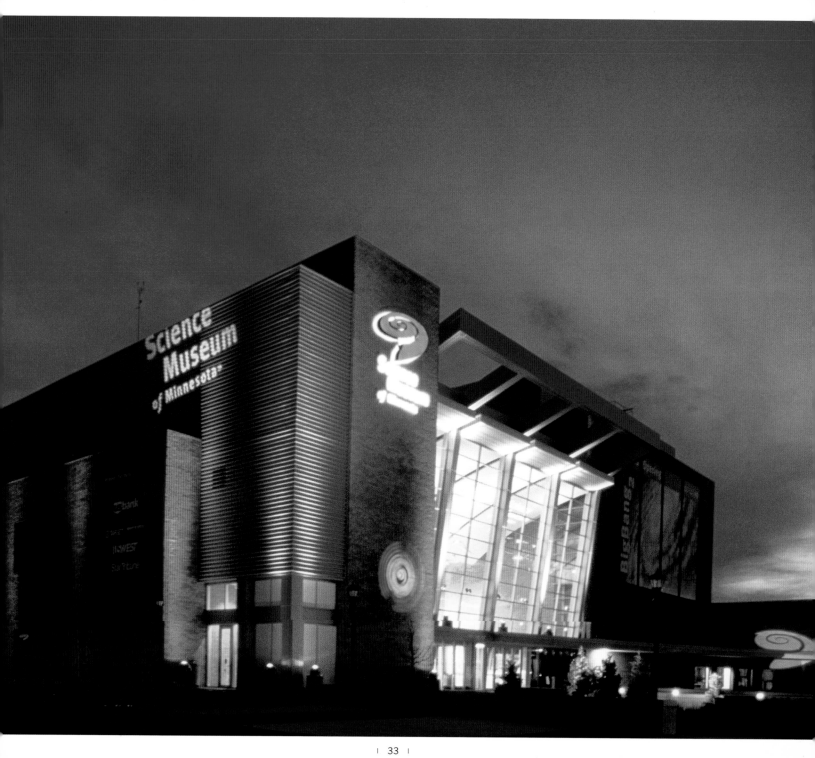

*Right:* A series of bas-relief sculptures titled *Journey of the River and the Sun* rises above ornamental flowers at Concord and Wabasha streets. This tribute to the settlement of St. Paul's west side is part of a public art program that encourages the use of recycled and salvaged materials.

*Below:* Multitudes of jonquils and daffodils adorn the grounds at the Minnesota Landscape Arboretum in Chanhassen.

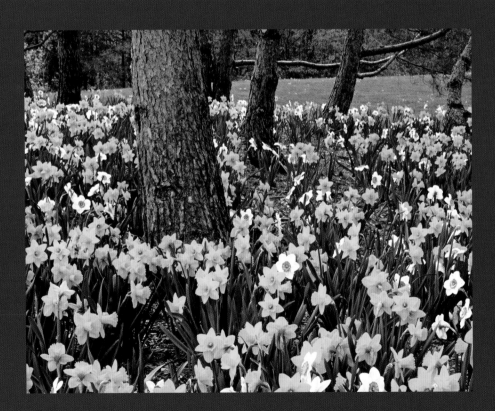

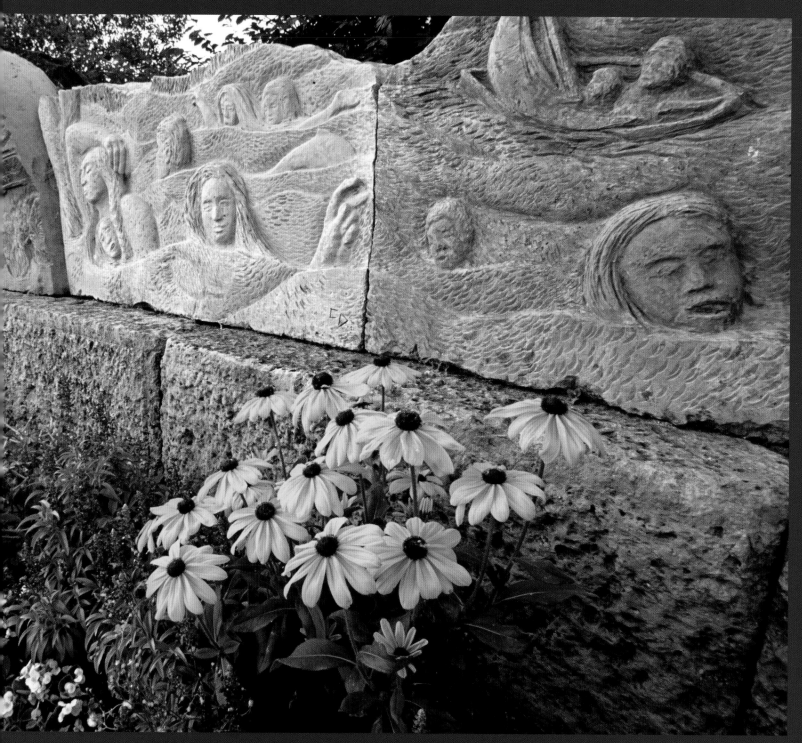

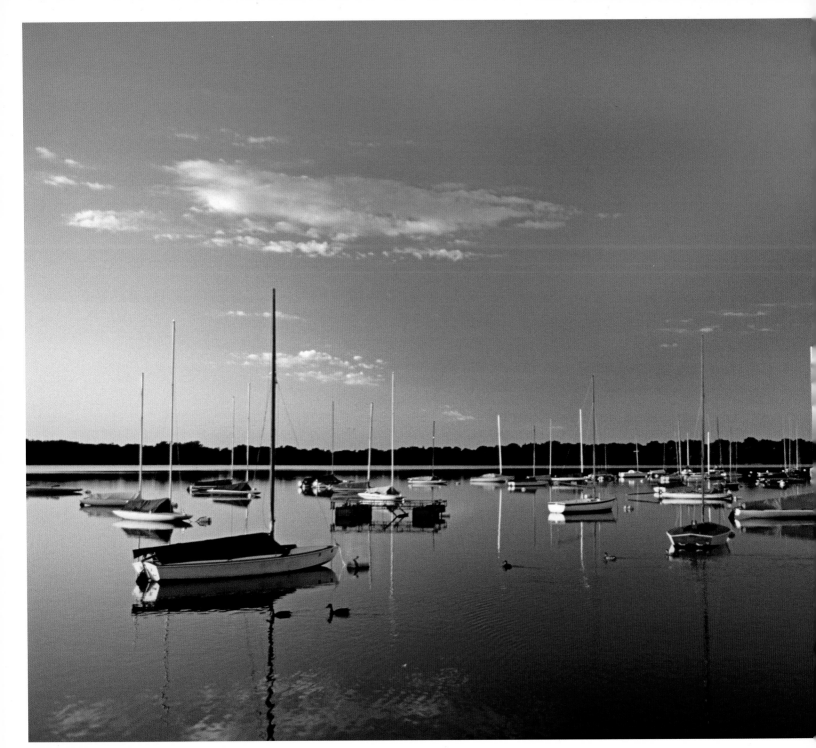

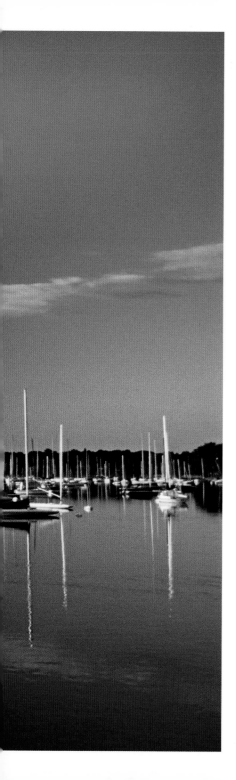

*Left:* A quiet moment on Lake Harriet seems to double the lengths of the sailboat masts.

*Below:* The center of Minneapolis isn't just for commerce. Windsurfers find plenty of action on Lake Calhoun.

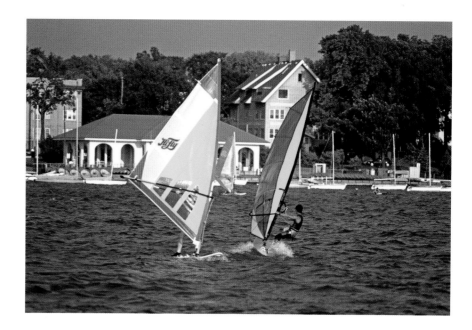

*Right:* Autumn brings special beauty to the St. Paul cityscape as it rises above the Smith Avenue Bridge and the Mississippi River.

*Below:* Immaculately maintained houseboats float at their moorings alongside Harriet Island in the Mississippi River.

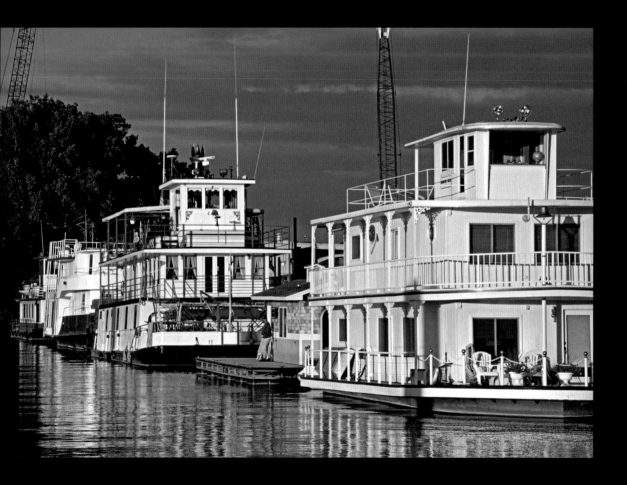

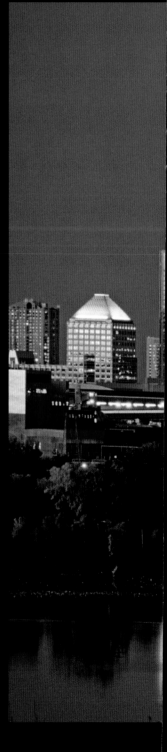

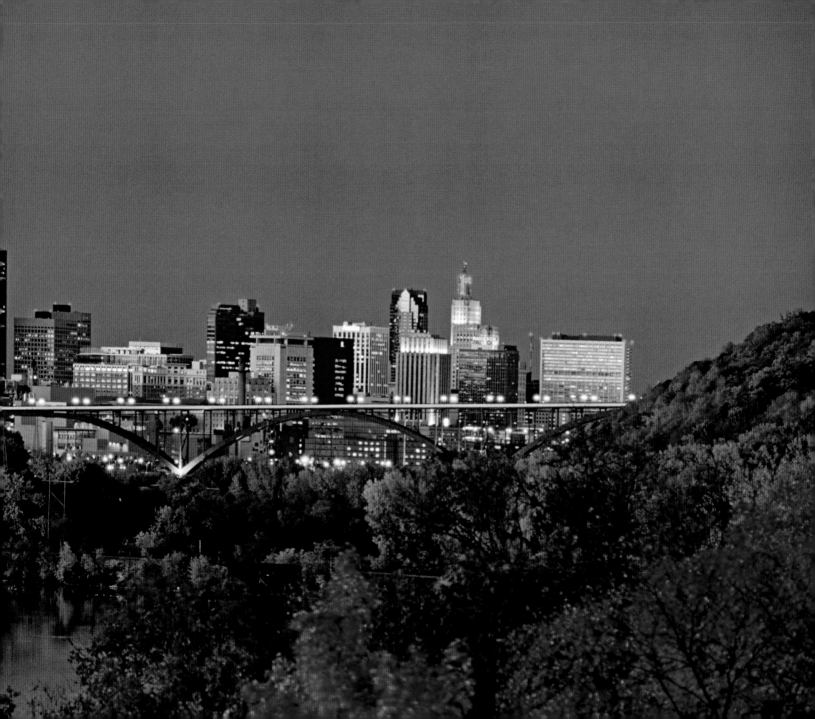

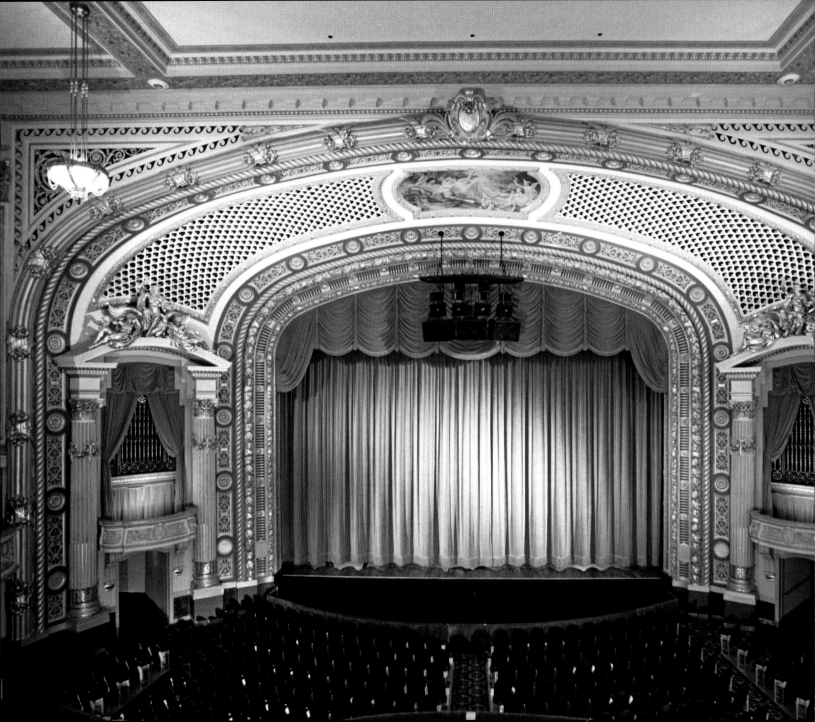

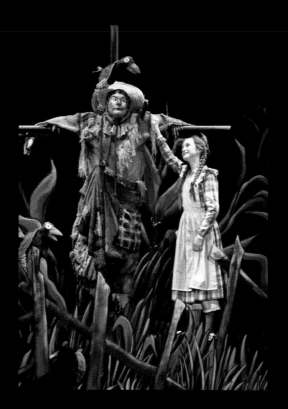

*Left:* Dorothy and the Scarecrow play a scene from *The Wonderful Wizard of Oz*, produced by the Children's Theatre Company in Minneapolis.

*Far left:* The State Theatre is in Minneapolis's historic Hennepin Theatre District. The restoration shows the luxurious detailing of this unique performance space that was state of the art when it was built in 1921.

*Below:* Penumbra Theatre Company actors perform a scene from *Black Nativity* at the Fitzgerald Theater in St. Paul.

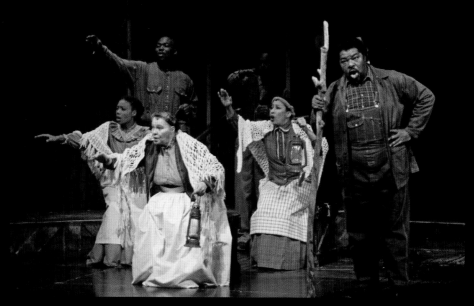

*Right:* Immaculately tended landscaping adorns the exterior of the Governor's Mansion, on Summit Avenue.

*Below:* Restaurants, movie theaters, and entertainment venues now characterize Minneapolis's Mississippi Riverfront. The historic St. Anthony Main area still sports brick sidewalks that lead to a variety of businesses.

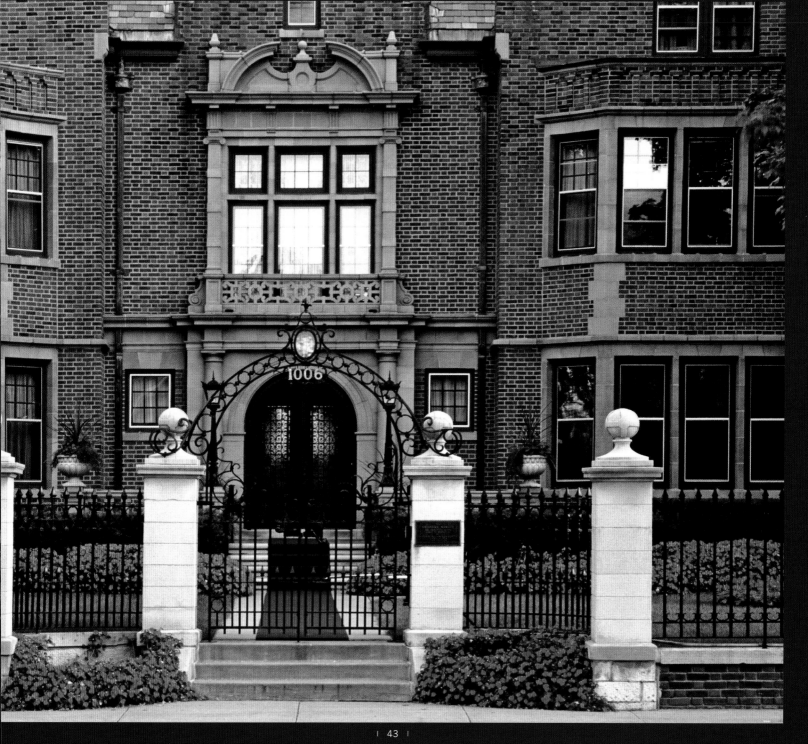

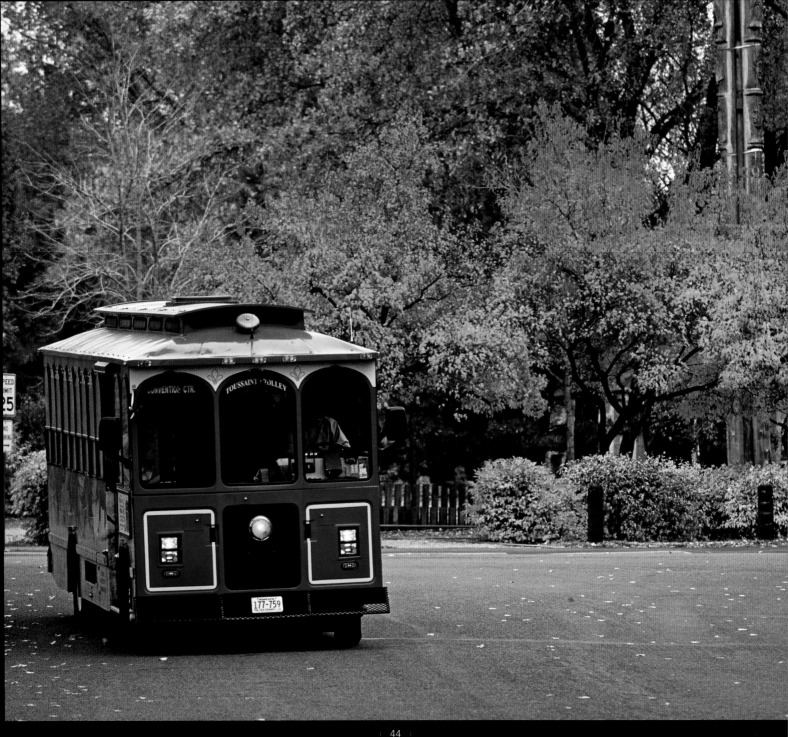

*Left:* Twin City Trolleys, this one in Nicollet Island Park along the Mississippi River, provide guided tours of the area.

*Below, left:* Berryland Farm Market sponsors a scarecrow contest in Cottage Grove, a suburb of St. Paul.

*Below, right:* A statue of Lucy is part of the Charlie Brown Around Town project that honors St. Paul–native Charles M. Schulz, creator of the comic strip *Peanuts.*

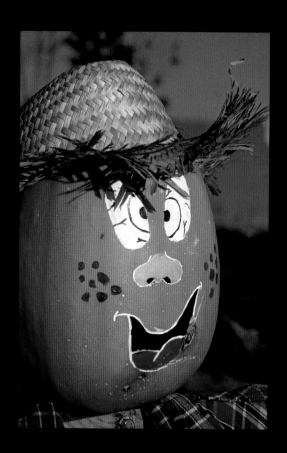

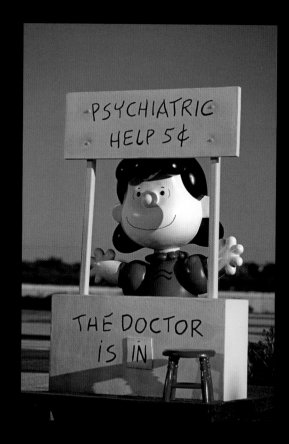

*Right:* The new houses the old at the Minnesota History Center in St. Paul.

*Below:* The Basilica of Saint Mary, in Minneapolis, was the nation's first basilica.

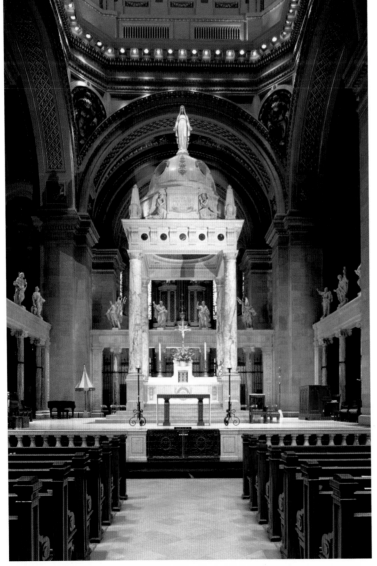

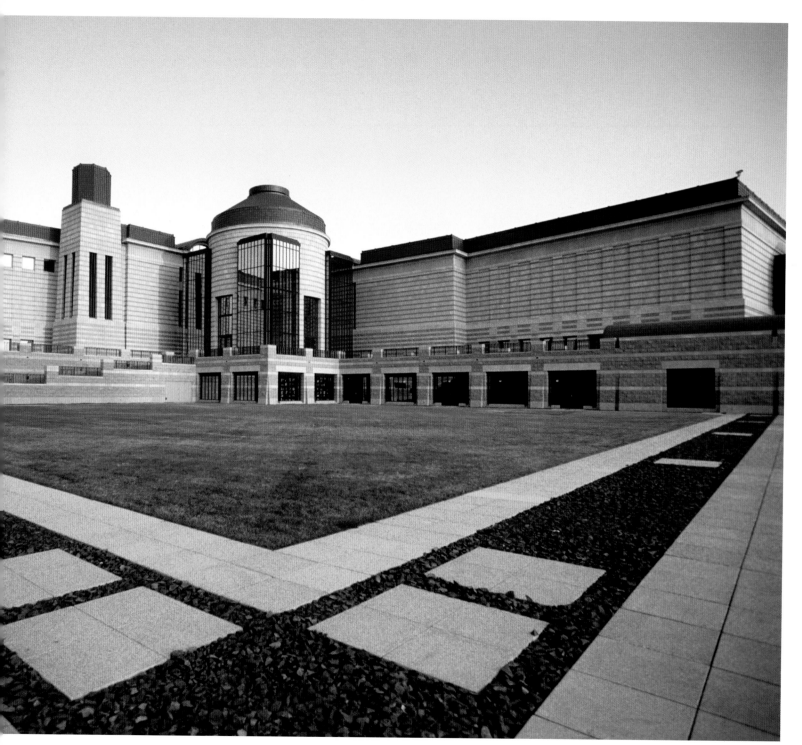

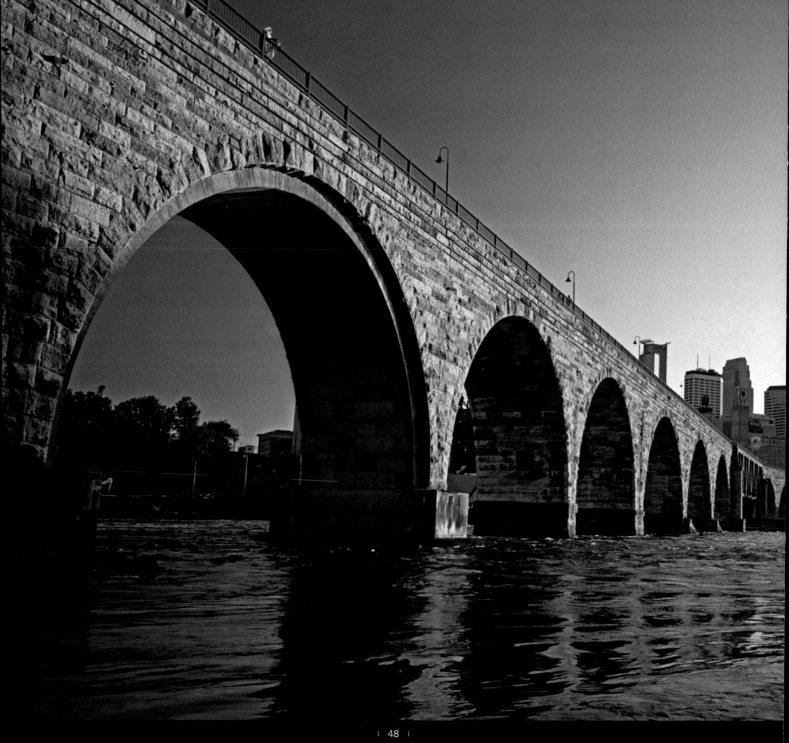

*Left:* Built in 1883, the James J. Hill Bridge across the Mississippi River is one of the most recognizable landmarks in Minneapolis.

*Below:* The sleek underside of the 1998 Wabasha Street Bridge and the St. Paul skyline, as seen from Harriet Island.

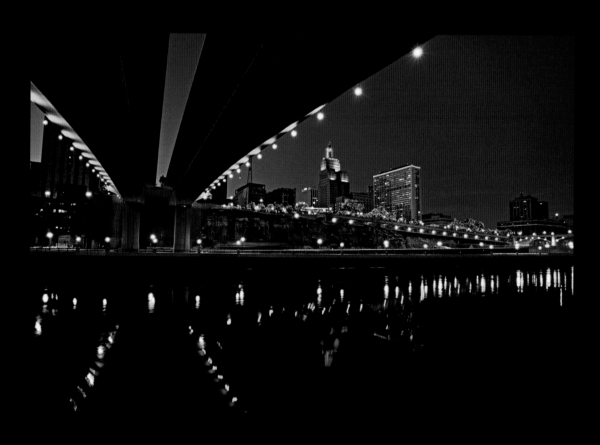

*These pages:* Reenactments and celebrations enliven summer days in the Twin Cities. The Minnesota Renaissance Festival in Shakopee induces a pretty gal to relax in the sunshine at her thatched Irish cottage, while others enthusiastically imbibe a different sort of relaxant.

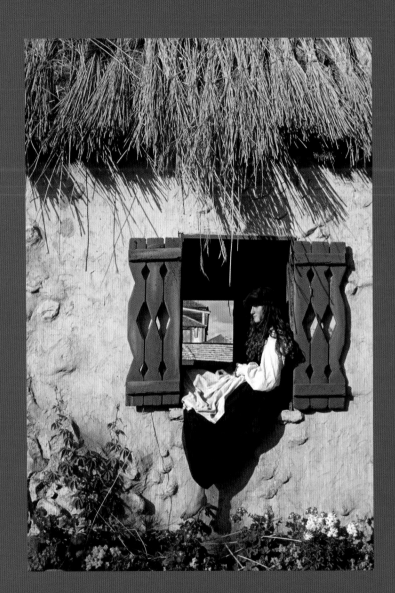

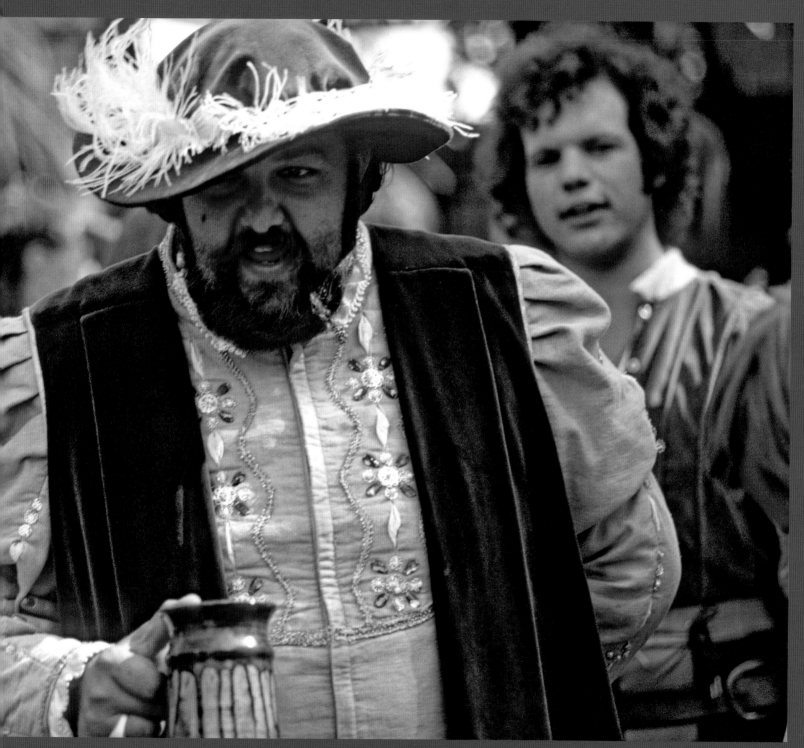

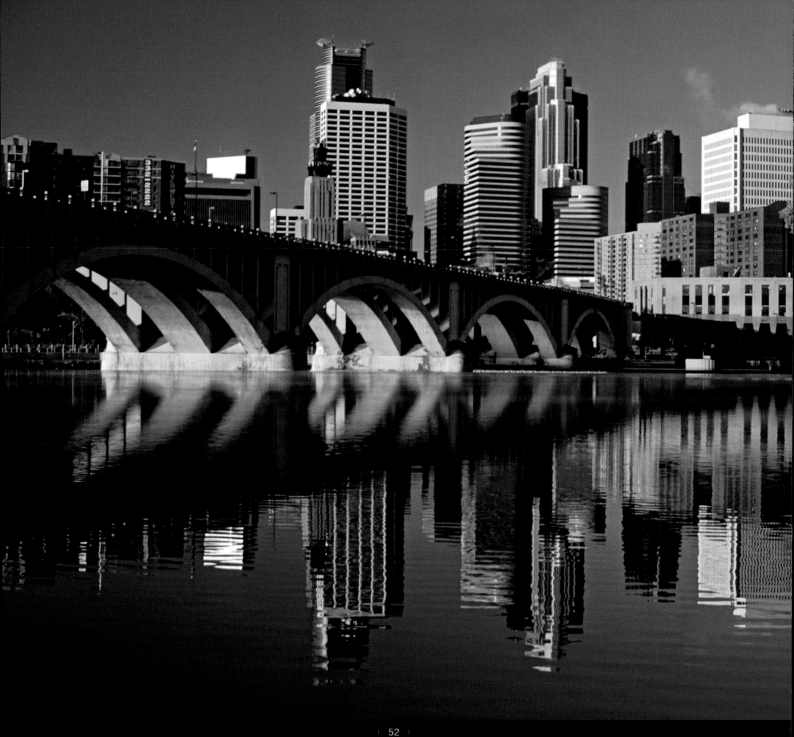

*Left:* A serene autumn sunrise illuminates Minneapolis near the Third Avenue Bridge.

*Below:* The stainless steel and brick Frederick R. Weisman Art Museum is impossible to mistake for any other structure.

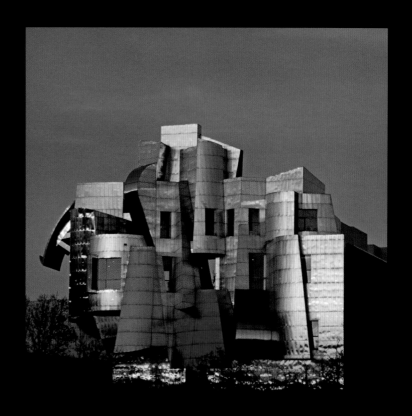

*Right:* Lights behind the Rum River Dam in Anoka give an otherworldly glow to the water.

*Below:* The 306-foot-tall Cathedral of St. Paul has a 120-foot-wide dome overlaid with copper.

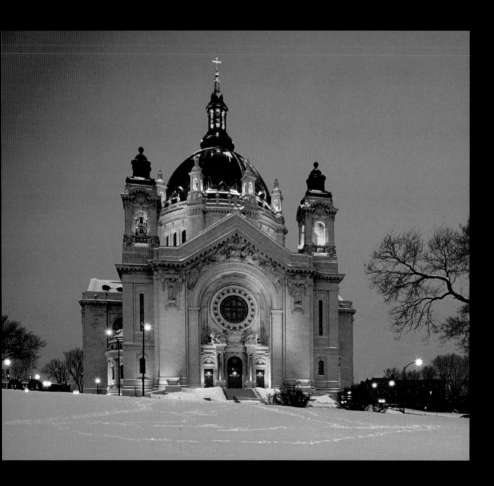

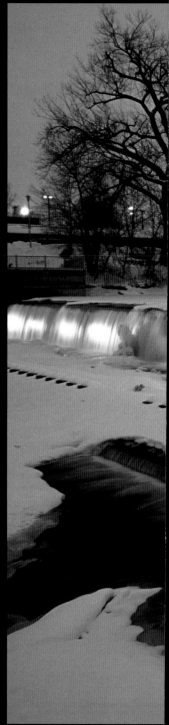

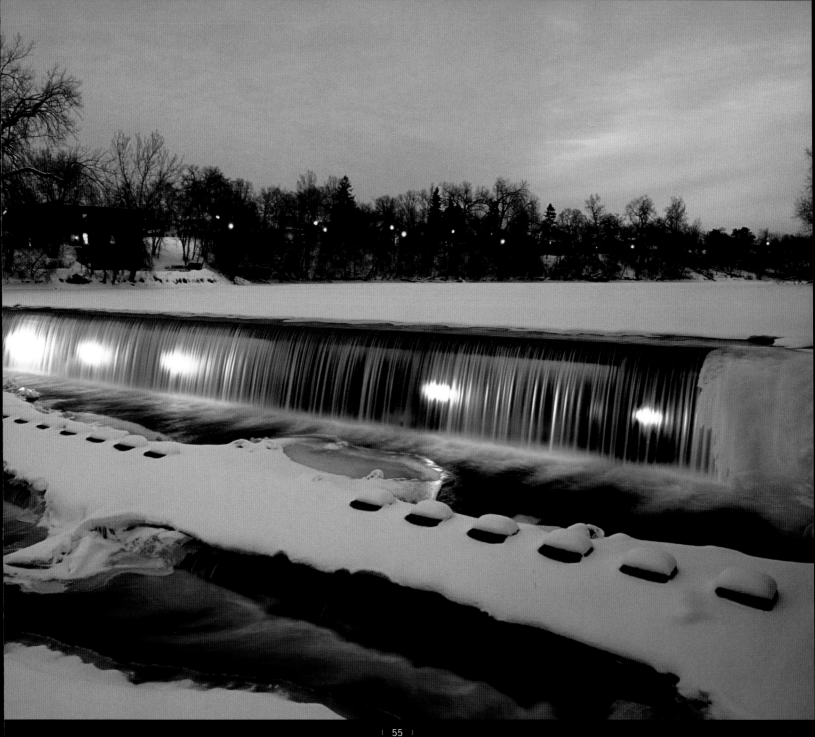

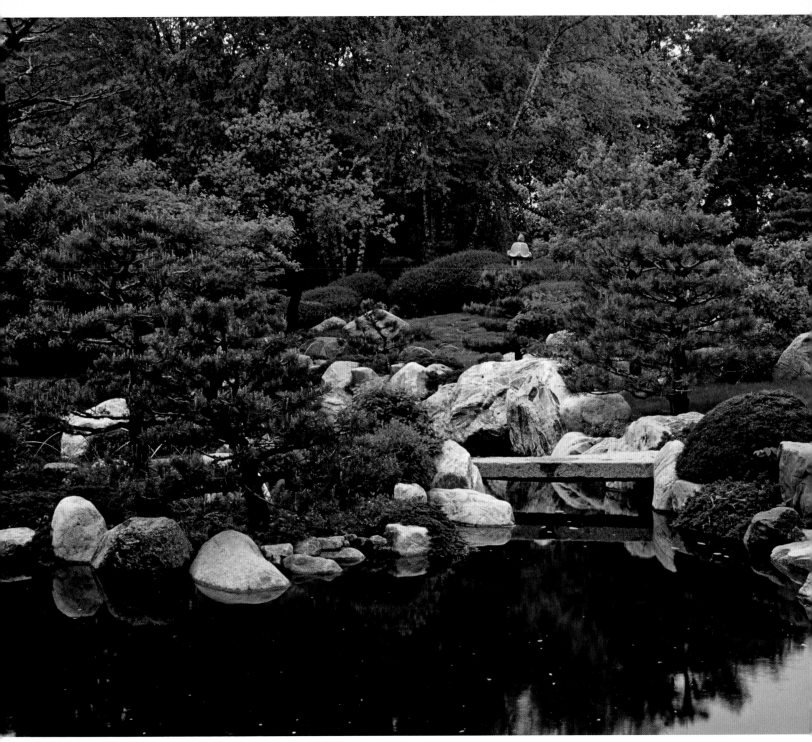

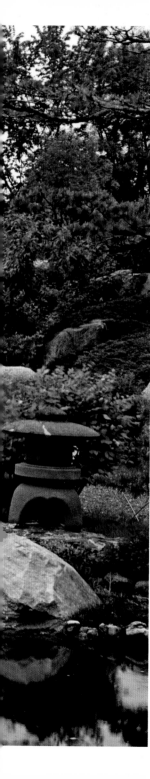

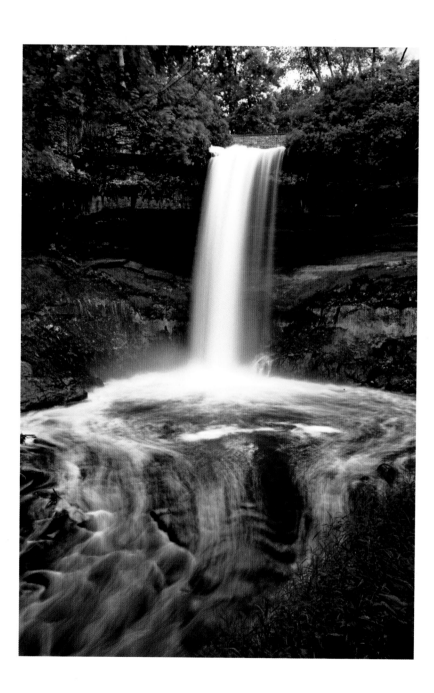

*Left:* Henry W. Longfellow's poem *Song of Hiawatha* mentions Minnehaha Falls, which pours over a limestone ledge in Minneapolis.

*Far left:* The Como Ordway Memorial Japanese Garden at Como Park in St. Paul is landscaped in the traditional Sansui mountain–and–water style.

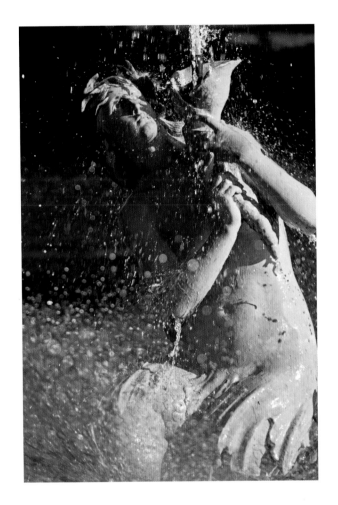

*Above:* Schiffman Fountain sprays water in Como Park, just south of the Lakeside Pavilion.

*Right:* The two-acre Japanese Garden adorns the grounds of Normandale Community College.

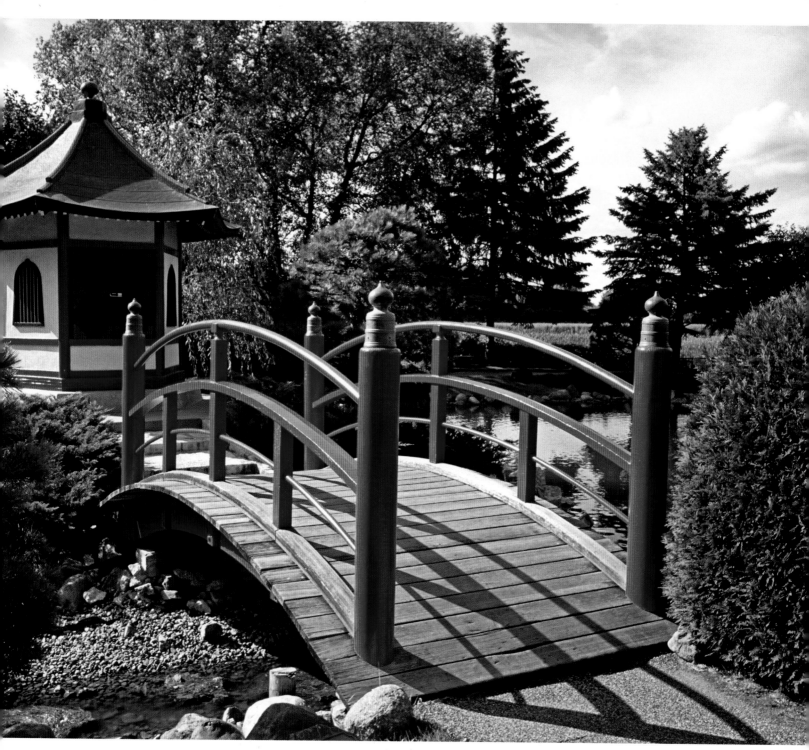

*Right:* A perfect evening trio: the moon, the Cathedral of St. Paul, and the state capitol.

*Far right:* Multicolored lights illuminate the stately columns outside the Minneapolis Institute of Arts.

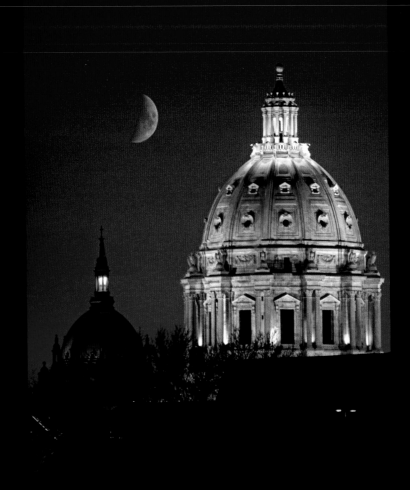

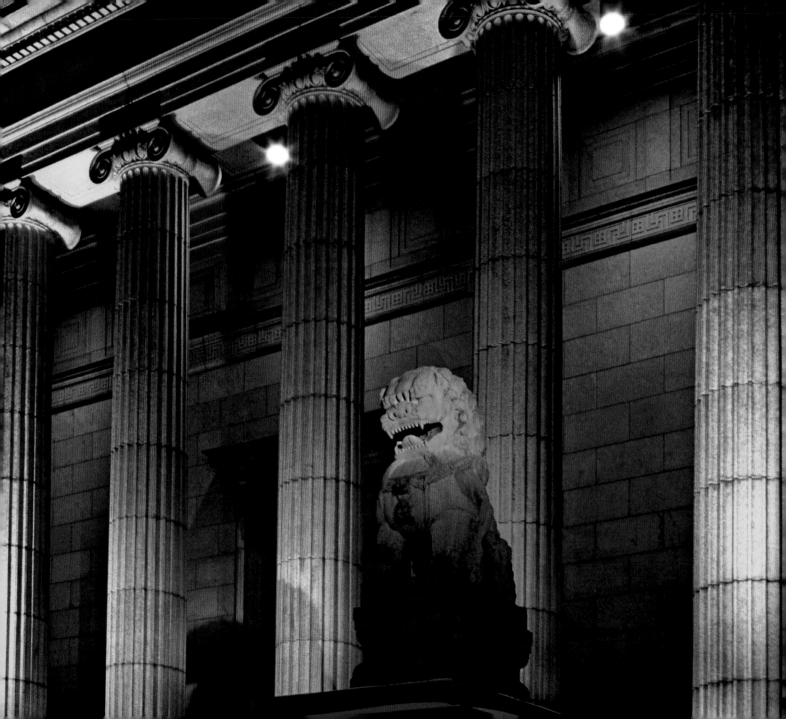

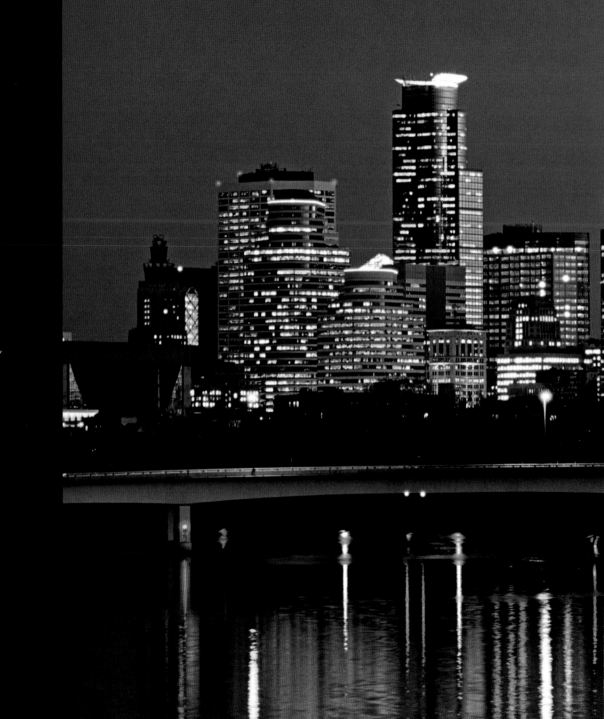

The Minneapolis skyline,
reaching for the stars.

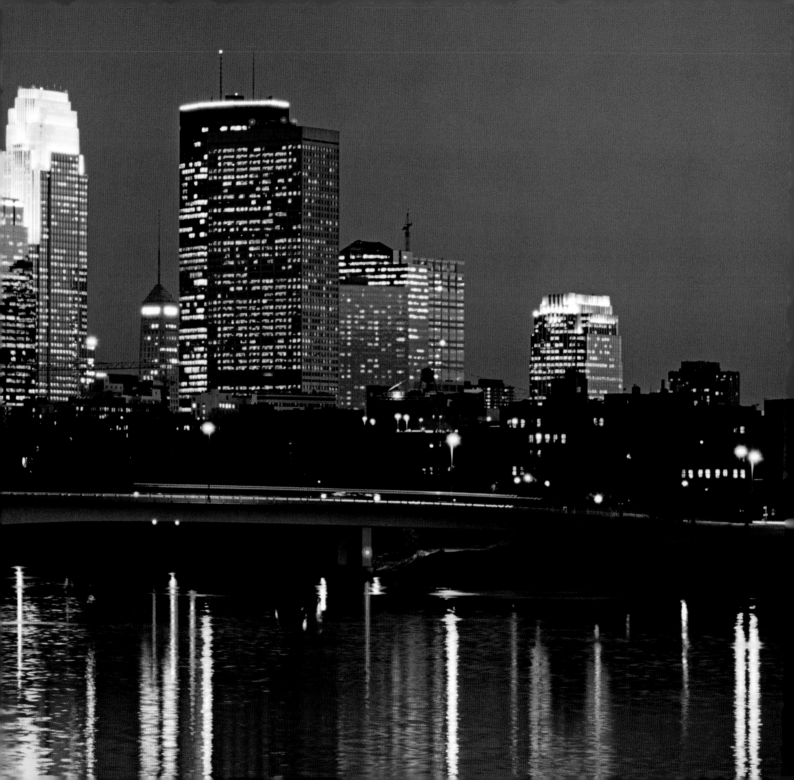

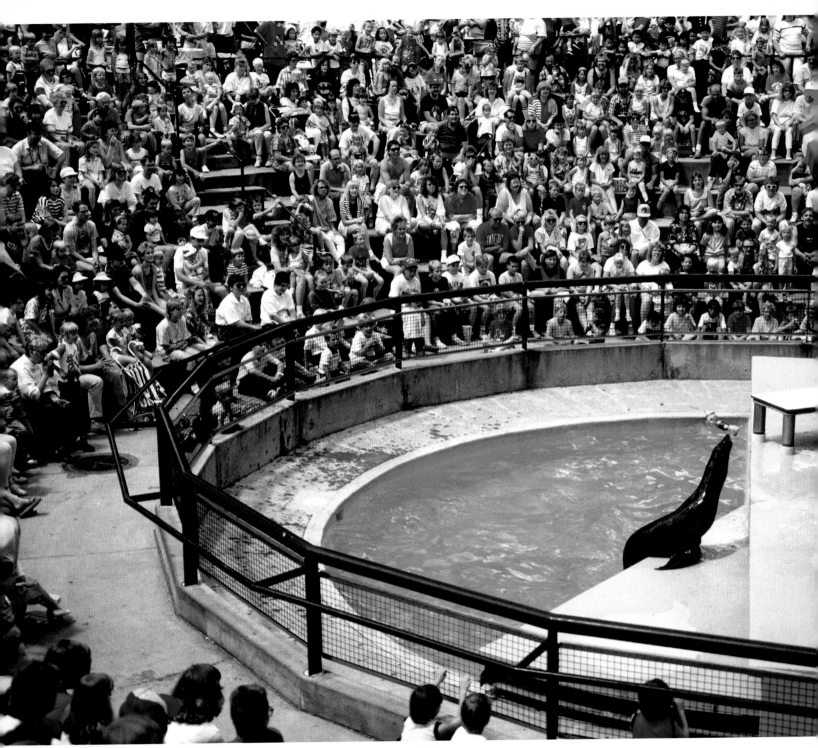

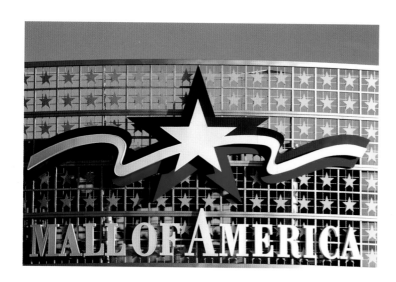

**Left:** The immense Mall of America in Bloomington has more than 520 specialty stores, 50 restaurants, and 14 movie screens.

**Far left:** A performing seal delights audiences at the Como Zoo in St. Paul.

**Below:** Young performers in the local group El Ballet Mexicano Infantile demonstrate a traditional Mexican dance at the Minnesota History Center in St. Paul.

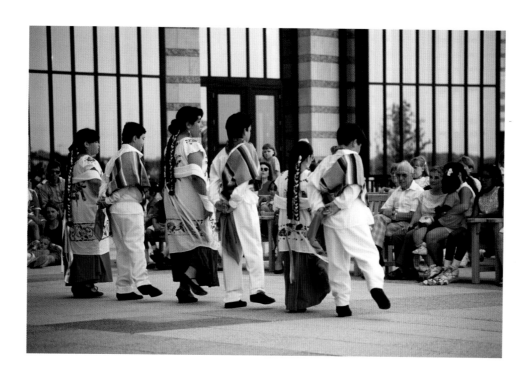

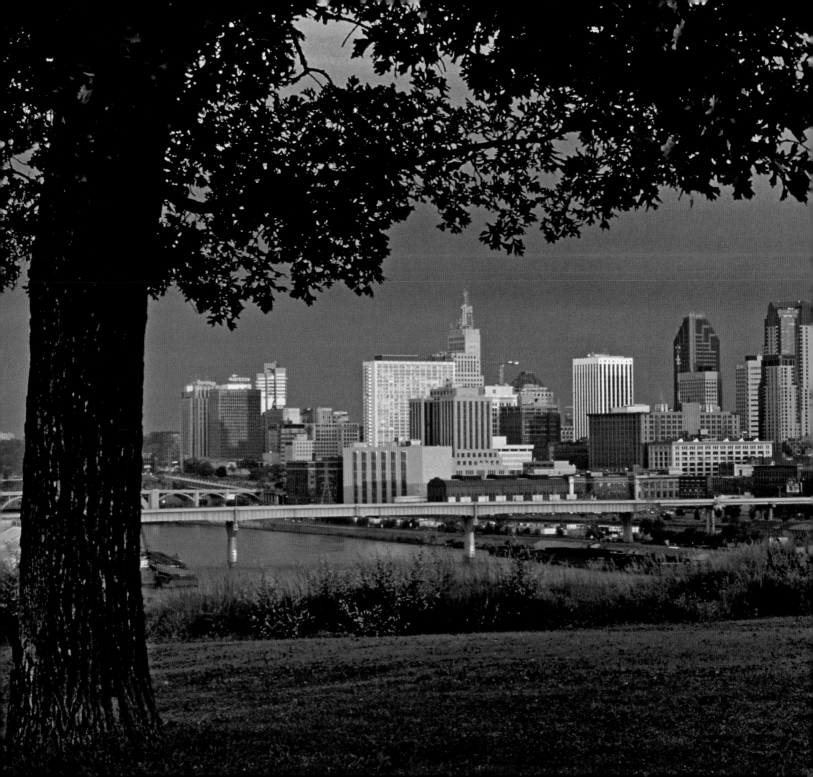

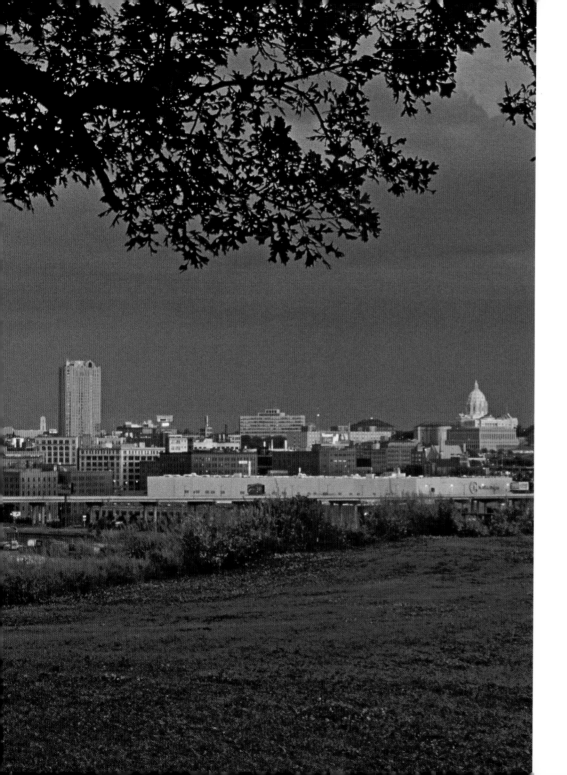

Sunset casts a golden glow
on the St. Paul skyline.

*Right:* At the University of St. Thomas campus in St. Paul, this six-foot sphere of seven connected figures titled *Constellation Earth* symbolizes the seven continents.

*Far right:* A unique exterior of crinkled aluminum mesh and other innovative features define the Walker Art Center in Minneapolis.

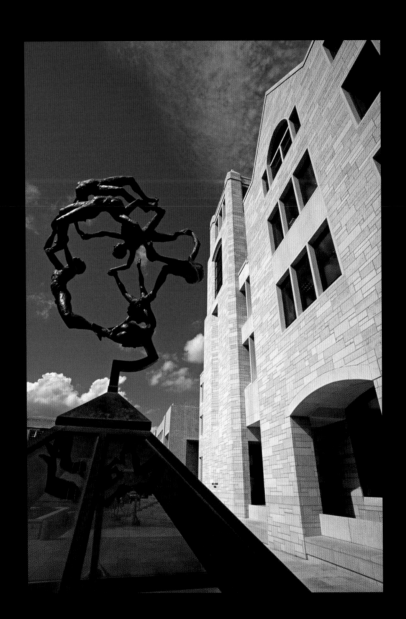

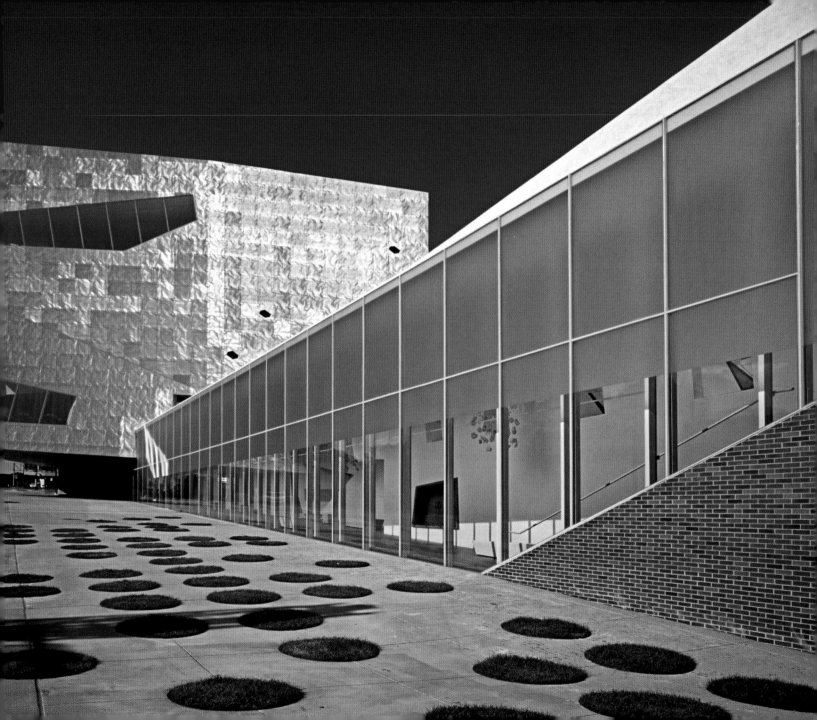

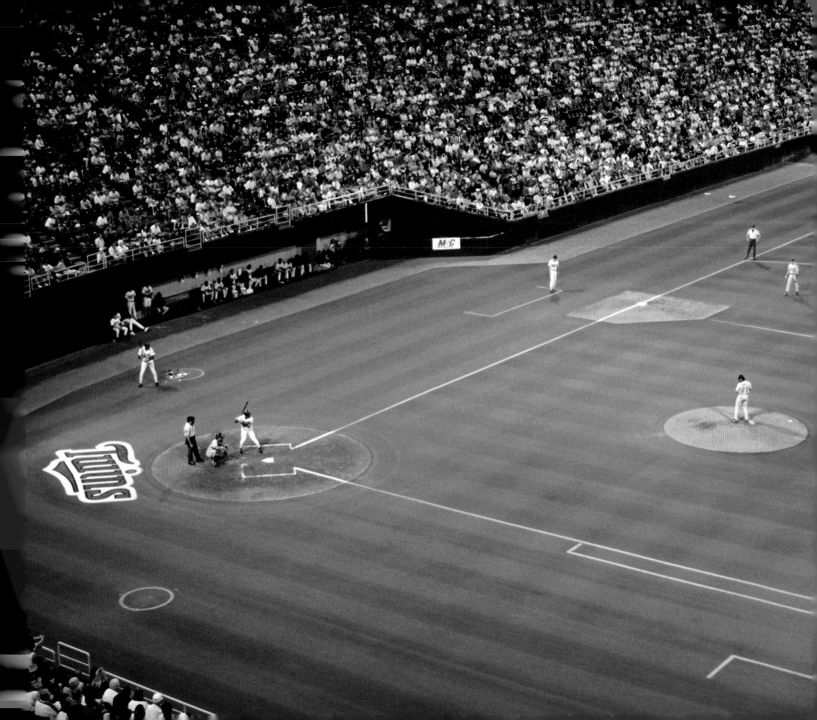

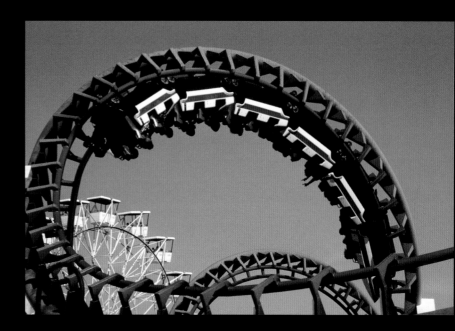

*Above:* Only the very brave get on the thrilling Corkscrew at Valleyfair Amusement Park in Shakopee.

*Left:* There's no better way to spend an evening than watching the Minnesota Twins in action on their home turf at the Metrodome in Minneapolis.

*Right:* Barge traffic is still an important component of commerce in the Twin Cities.

*Below:* Autumn leaves create a colorful street scene in the Highland Park neighborhood of St. Paul.

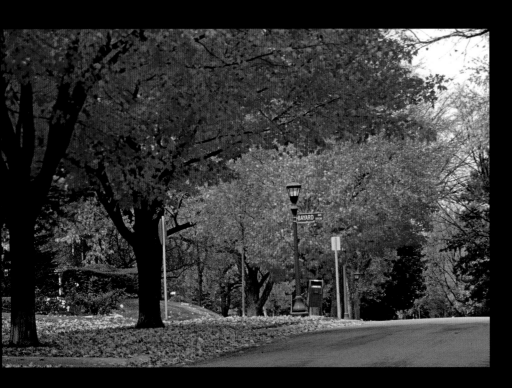

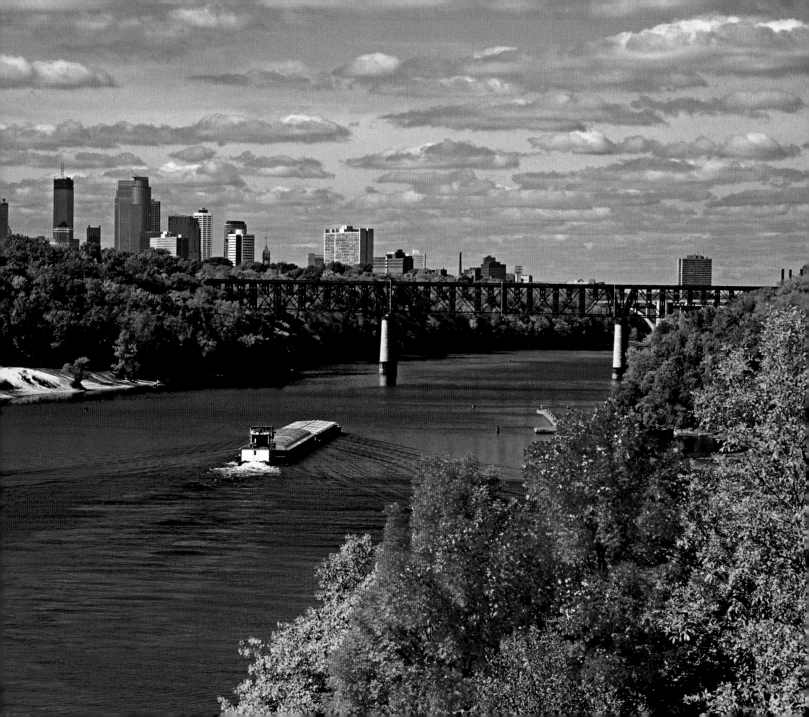

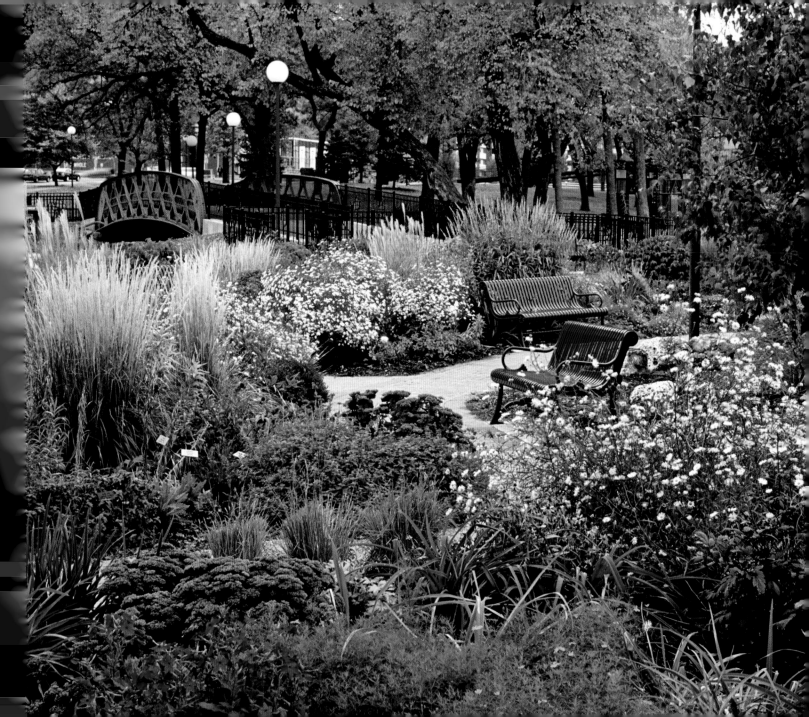

his sweetheart Pocahontas. Minnehaha Park was established as a city park in 1889.

*Below, right:* This twelve-foot-tall sculpture titled *The Time Being* is displayed on the grounds of the Federal Reserve Bank of Minneapolis.

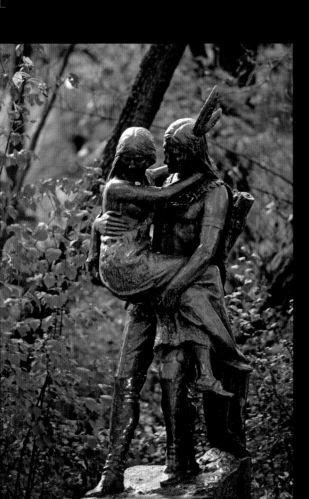

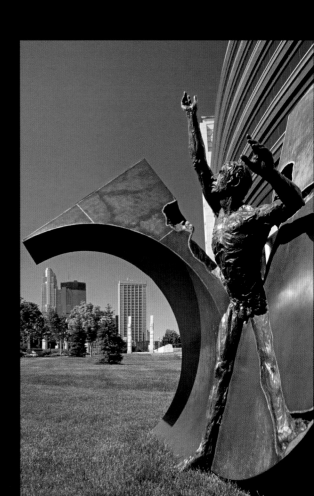

*Right:* Early morning is a fine time for a brisk walk around Lake Phalen in St. Paul.

*Below:* The Minneapolis skyline provides the scenic background for golfers at Theodore Wirth Golf Course.

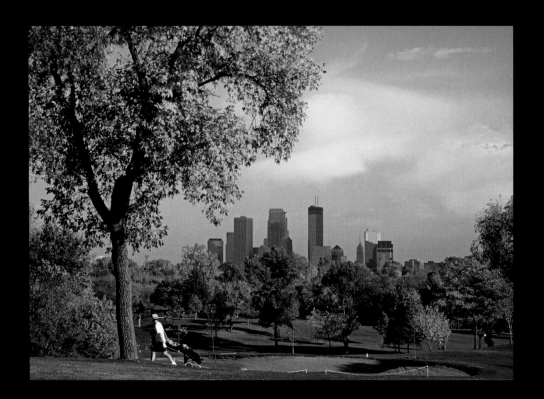

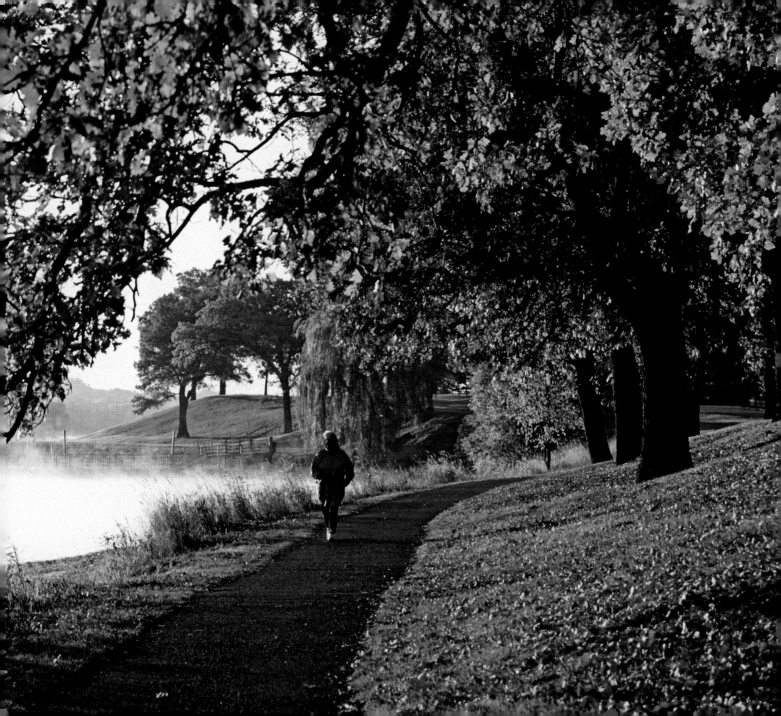

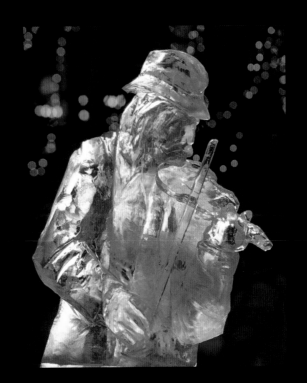

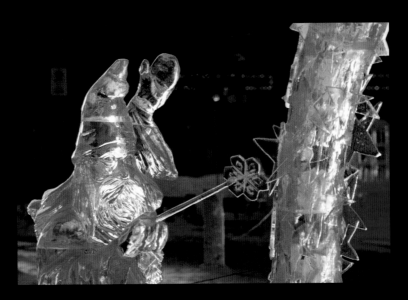

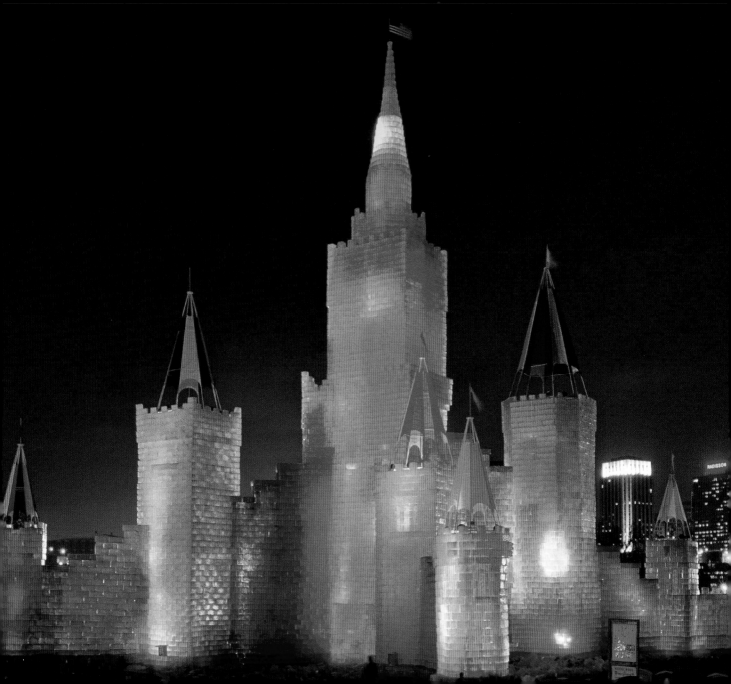

**Greg Ryan's** first loves were the
woodlands and the waters of Minnesota.
Photography became his avocation and
a tool for discovery; his greatest joy
came from the quest, searching for
and sharing the beauty of the places
and people that surround us. At the
age of forty, Greg followed his heart
and became a freelance photographer.
His editorial, travel, commercial, and
stock images have appeared in national
and international publications, and he
has published five books on Minnesota
and the Twin Cities.

*Right:* A long exposure defines the turbulent flow

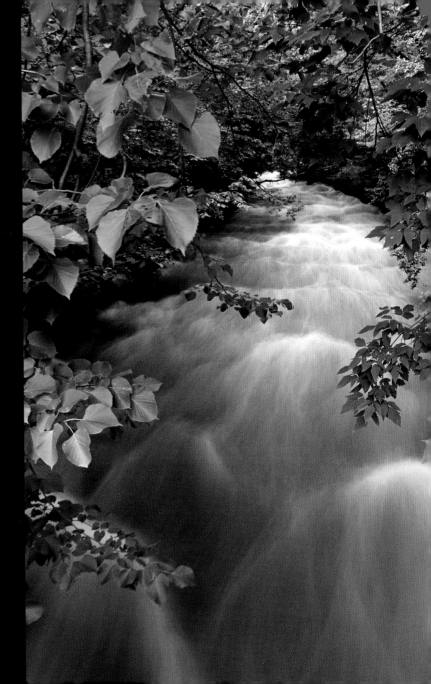